C000132198

TBSHS LIBRARY

This book is due for return on or before the last date shown below.

TBSHS Library

021981

Metals

RotoVision

This book is dedicated to my wonderful family, each and every one of you.

Metals

Materials for Inspirational Design

Chris Lefteri

A RotoVision Book
Published and distributed by RotoVision SA
Route Suisse 9
CH-1295 Mies
Switzerland

RotoVision SA, Sales, Editorial
& Production Office
Sheridan House, 112/116A Western Road
Hove BN3 1DD, UK

Tel: +44 (0)1273 72 72 68
Fax: +44 (0)1273 72 72 69
Email: sales@rotovision.com
www.rotovision.com

Copyright © RotoVision SA 2004

All rights reserved. No part of this publication
may be reproduced, stored in a retrieval system
or transmitted in any form or by any means,
electronic, mechanical, photocopying, recording
or otherwise, without permission of the copyright
holder.

10 9 8 7 6 5 4 3 2

ISBN 2-88046-762-4

Edited by Becky Moss
Book design by Lucie Penn
Cover design by Luke Herriott
Photography by Xavier Young

Reprographics in Singapore by ProVision Pte. Ltd.
Tel: +656 334 7720
Fax: +656 334 7721

Printed and bound in China by Midas Printing Ltd.

Contents

Metals are brilliant, metals are fantastic, metals are strong, shiny, and reflective. They don't age if you use them properly, and if they rust they can still be beautiful. Our buildings are made of metal but this is not something that many people would think about; metals are the real building blocks of architecture, providing for and supporting the more visible materials. Metals were the catalyst for the industrial revolution, transforming our landscape. Metals are many things but, for me, metals were and are my clay.

I never considered myself to be a designer and I knew for sure that I wasn't a craftsman. I always wanted to make things but I thought that you had to be a craftsman to make furniture and products in wood and ceramics. For some reason, I didn't think this extended to metals so I started making things in metal. You could say I was sucked into design through metal. I took to it readily, partly because it's such a forgiving material—you can do amazing things in metals without the need for the skill of a glass-blower, for example, or the detailed knowledge and experience of an expert on processing. You can join it and hide the join; you can shape it and you can polish it, and you can add almost anything to it. It's much easier to correct mistakes made with metal than with wood.

Also, metal can be very suggestive. When I first began to design in metal, there was often a dialog between my will and the will of the material, because metal reacts in a certain way to the blows of a rubber hammer. I enjoyed discovering how melted parts evolve together, and clearly remember the pleasure of using just a touch to burn into sheets of steel. The charm of those early pieces was contained in the fact that the designs didn't follow a blueprint or instructions—they were improvised, and this improvisation with metal suited me very well.

These first pieces were done by unskilled people: myself and those I was working with at the time. We got better and better at understanding metals as time went on, but these first designs—like "Big Easy", for example—were really very crude; I look at some of them now and I can't believe we did them. Our recent pieces have come so far—they are so polished they are like pieces of jewelry. But our new collections are made according to the same principles; we just just developed our processing methods as we've learnt and continue to learn what this incredible material is capable of.

We use metals for many projects and constantly push the boundaries of what we can achieve; we continue to tease metals by creating composites with other materials: for example, with projects like "Bookworm", where we started with a metal piece which was then imitated in plastic, and the Well Tempered Chair which people are pleasantly surprised to find is bouncy (p031).

Metals also fit clearly into the idea of there being four ways of making objects. You can create waste by removing material to leave the metal you want to use. Metal also lends itself to casting; it easily changes between consistencies with a change in temperature, allowing for it to be cast and molded. It can also be formed using anything from a hammer to a press tool. This process takes metals from flat forms, bending them to a shape and therefore a function. The fourth way is by assembling metals to metals using joints and screws. A further use for metals is in creating prototypes, but this is still in its infancy. These earthly materials will always fascinate and inspire, as they continue to surprise us, transform our environments, and improve the quality of our lives.

Ron Arad

Well Tempered Chair
Designer: Ron Arad
Manufacturer: Vitra
International Switzerland
Date: 1986

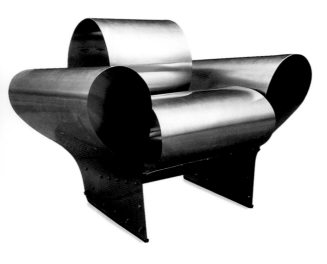

Foreword

My most memorable classes in school were in science. Our teacher would bring out samples of various elements to show us the chemical reactions that take place when they are heated, put in water, mixed with acid and so on. My favorite element at that time was mercury—it certainly had the "wow!" factor for me, probably because it was liquid at room temperature. I always wanted to take the thermometer home and break it open just so I could push the liquid mercury around on the kitchen table and dream about the myriad uses I could find for this fascinating metal. Then I discovered that if you put a toy car into the dying hot coals of the barbecue, the zinc chassis would soon melt into this same mercury-like liquid. I later saw this effect in the movie Terminator 2, where second-generation Terminators were transformed into liquid metal. I don't think I've ever lost my fascination with this incredible, but very toxic material, along with countless other materials.

There are more materials available to us today than ever before. About three quarters of the elements in the periodic table are metals, about half of which are commercially important. From this relatively small number of elements, we have managed to cook up at least 10,000 varieties of alloys. So what are metals? The engineer's definition is based on their mechanical and physical properties: they conduct electricity and heat, they are strong and tough, they are stable over long periods of time, and they are opaque. But it is important to differentiate between pure metals and their alloys. Most of the metal products you see are alloys of various kinds. An alloy is a metal composed of two or more elements blended together to create enhanced physical and mechanical properties. Take stainless steel for example, a material that is as much a part of our everyday existence as wood, plastic or glass. This combination of iron, chromium, and nickel transforms plain carbon steel into a harder, non-rusting alternative.

Some metals are essential dietary elements. Zinc and magnesium, for example, provide the strongest and closest relationship between the material world and our physiology; they are both essential and unavoidable. Magnesium (the sixth most abundant element) and its alloys are strong and lightweight, making them ideal materials for aircraft structures, camera bodies, portable tools, and casings for portable computers. But magnesium is also known as nature's tranquilizer and has major benefits for the human body, as does zinc, which boosts the immune system and promotes healthy skin and sperm. Mercury, of course, is a deadly toxin, the term "Mad as a Hatter" or "Mad Hatter" comes from when hatters were consistently exposed to high levels of mercury when polishing top hats. Copper can be both toxic and beneficial depending on the amount ingested.

As with all the books in this Materials series it is not just the discovery of new or advanced materials that provides inspiration but also the new applications and forms these materials take. Take a look at the superelastic aluminum alloys that we see in Ron Arad's chair (p083), where a sheet of aluminum behaves like a piece of plastic and follows the latter's ability to be heated, softened and pulled over mold; or the memory alloys that behave more like a piece of rubber than a strip of metal (p062/063), allowing for strips to be bent into extremely tight curves before bouncing back to their former shape when released.

Metals are in the air we breathe, the food we eat, and the packaging around it; we live and work in metal buildings, we travel in metal containers, and we wear metals on our bodies; metals are in our water and in our soil. We are closer to metals than any other material; metals are in our blood. We exploit metals in so many different ways yet how often do we really look at them? Without a doubt, most of us take their extraordinary benefits for granted, and when we do appreciate them, it can often be distorted by the monetary value we have imposed upon them. We forget that metals come from the earth, and are largely ignorant of the processes that metals go through, and the hardships that people endure for our everyday benefit. Metals will always engage and fascinate us with their strength, versatility, and inherent beauty, yet we are desensitized and conditioned not to question the intrinsic properties of these raw materials. I hope this book will go some way to redress the balance, provoke some interesting discussion, and inspire new ideas of exploring one of our most ancient and precious of materials, metal.

Preface

How to use this book

This book continues the celebrated Materials series by offering the inquisitive reader a rich and unique introduction to metals. The chapters fall into two main sections. The first section features a range of projects, products, and processes which look at samples of metals in various forms, featuring some everyday products and some which have never been published before. Each page or spread features a different product. The information for each feature is divided into three layers of basic information, with text that is deliberately easy to digest. For those who would like more in-depth technical knowledge, each page contains details of where to find more information, usually given as a website.

The contact details on each page provide leads to further information. These details may not necessarily be the producers of the product described, but indicate a good place to start further research. These are only a guide—in most cases, they are by no means the only suppliers of the material. A reference guide is also included on each page for cross-referencing to similar materials or processing methods on other pages. The 'Key Features' section on each page breaks down the material or process into its basic properties. 'Typical Applications' contextualizes the material by suggesting other areas where the material or process is used.

The second section of this book is a reference guide to the most common metals in general use. It gives specific information on types of metals and production methods. There is also a list of web links to key metal producers, associations, and material suppliers, as well as a millimeters to inches conversion table. The purpose is to offer a taste of some of the most interesting materials out there and list where to get hold of them, so please browse, enjoy, and tuck in to some of the most inspiring metals.

013 Materials

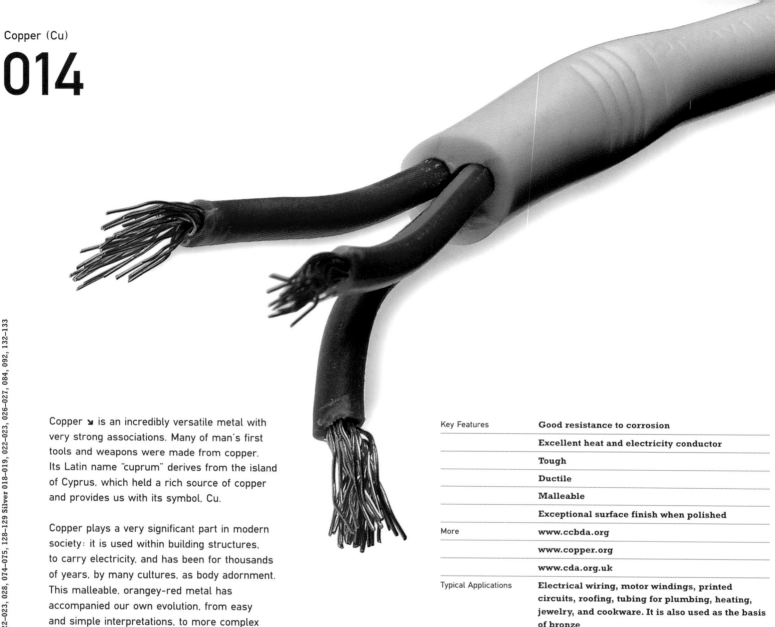

Copper (Cu)

014

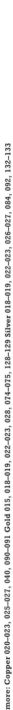

Copper ↘ is an incredibly versatile metal with very strong associations. Many of man's first tools and weapons were made from copper. Its Latin name "cuprum" derives from the island of Cyprus, which held a rich source of copper and provides us with its symbol, Cu.

Copper plays a very significant part in modern society: it is used within building structures, to carry electricity, and has been for thousands of years, by many cultures, as body adornment. This malleable, orangey-red metal has accompanied our own evolution, from easy and simple interpretations, to more complex applications, such as its vital role within modern communications.

Next to silver ↘ it is the best conductor of electricity and second only to gold ↘ in terms of how long we have been making use of it. This is largely due to the ease with which it can be separated from its ores and mined.

Key Features	Good resistance to corrosion
	Excellent heat and electricity conductor
	Tough
	Ductile
	Malleable
	Exceptional surface finish when polished
More	www.ccbda.org
	www.copper.org
	www.cda.org.uk
Typical Applications	Electrical wiring, motor windings, printed circuits, roofing, tubing for plumbing, heating, jewelry, and cookware. It is also used as the basis of bronze

Standard three-core flex
electrical cable

Partner for humanity

↑

Modern material

Compared to gold ↘ which has been used for the last 9,000 years, this white metal, with a hint of blue, is a mere infant. Aluminum ↘ was first produced and named at the beginning of the 18th century. Unlike many other metals, it does not occur naturally in its metallic form but is produced from bauxite, which contains 50 percent aluminum oxide (or alumina). It is in this form that aluminum exists as one of the most abundant metals on earth.

When aluminum was first produced, there were no immediate uses for it and new products were developed and markets explored to find a use for this high-tech material. However, even though it has only been used relatively recently, more aluminum is produced now than all the other non-ferrous metals combined.

Dimensions	**511mm high x 206mm wide x 475mm deep**
Key Features	**Ductile**
	Easily forms alloys
	High strength-to-weight ratio
	Excellent corrosion-resistance
	Excellent heat and electricity conductor
	Recyclable
More	**www.world-aluminum.org**
	www.aluminum.org
	www.eaa.net
	www.alfed.org.uk
ore	**www.ingo-maurer.com**
Typical Applications	**Vehicle construction, aircraft parts, kitchen utensils, packaging, and furniture. Aluminum is also used for strengthening large structures including the Statue of Eros in Piccadilly Circus, London, and the top of the Chrysler building in New York**

Apple Power Mac G5
Designer: Apple Design Studio
Date: 2003

more: Aluminum 024–025, 034–035, 038–041, 044–045, 048, 053, 060–061, 064–069, 074–075, 078, 080–083, 094–095, 108–109, 112–113, 120–121, 138–139 Gold 014, 018–019, 022–023, 028, 074–075, 128–129

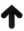

016

Flow

Manhole covers easily blend into the background of our everyday environments, rarely noticed or given a second thought by most of us. One of the key features of cast iron and the reason for its prolific use for so many years is its exceptional fluidity, and its ability to take on complex, intricate shapes ⬎. Cast iron is the generic name for a group of materials made from carbon, silicon, and iron ⬎. A high carbon content ensures good flow characteristics during casting, and is present in two forms, graphite and iron carbide.

The presence of graphite in cast iron gives manhole covers their excellent wear-resistance. Rust ⬎ is generally superficial and is constantly polished off by wear. However, to deter rust, the castings are covered with a bitumen coating which fuses with the porous iron. This traditional process of producing sand-cast materials is being used by many contemporary designers in more and more exciting new applications.

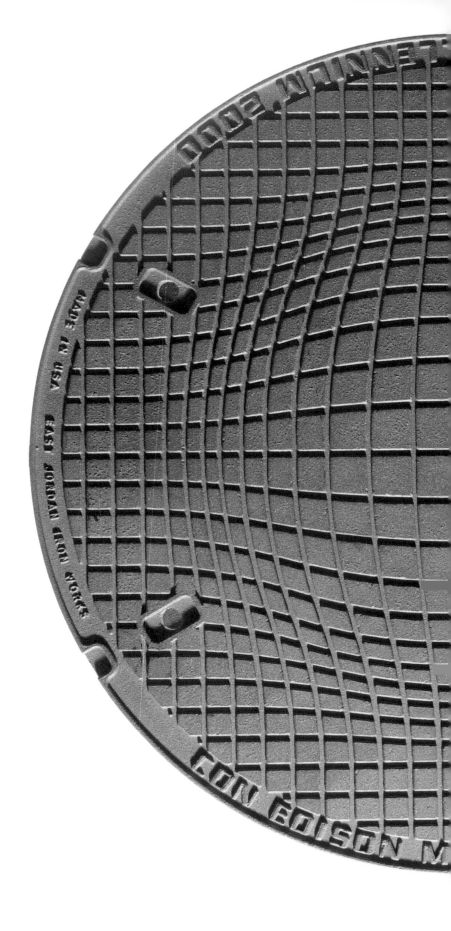

Dimensions	810mm diameter x 100mm deep
Key Features	**Excellent fluidity**
	Cost-effective
	Good wear-resistance
	Low solidification shrinkage
	Brittle
	Good compression strength
	Good machinability
More	**www.karimrashid.com**
Typical Applications	**Cast iron has been used for hundreds of years in buildings, bridges, engineering components, furniture, and kitchenware**

Millennium manhole cover for
New York City
Client: Con Edison
Designer: Karim Rashid
Date: 2000

more: Iron 022–023, 029, 031, 104 Rust 110–111 Shapes 034–037, 046–047, 050–051, 084

(right) Cylinda line hot
water jug, (far right)
Cylinda line teapot
Designer: Arne Jacobson
Manufacturer: Stelton
First produced: 1967

New domestic landscape

The evolution of tableware ⬎ provides us with a useful history of our materials and production methods, with metal taking center stage. Metal objects fall into two broad categories: firstly, we have basic, simple tools, created for necessity of function; secondly, we have the more ostentatious, ornamental, silver ⬎, and gold ⬎ artefacts. The development of mass-production techniques and the industrial revolution provided an opportunity for the basic and the ostentatious to coincide, and new materials gave designers the chance to revolutionize our domestic landscape.

There are four major types of stainless steel ⬎: austenitic, ferritic, ferritic-austenitic (duplex), and martensitic. The stainless steel used in domestic applications is generally austenitic. Stelton, founded in 1960, are well-known for their iconic, brushed stainless steel designs. Virtually all the products from this manufacturer boast a functional aesthetic; the clean, cylindrical, functional forms are as much to do with choice of material as the design. The combination of quality stainless steel and high production values raises these Stelton products to luxury status.

Dimensions	**Teapot 130mm high; Hot water jug 125mm high**
Key Features	**Hygienic**
	Non-corrosive
	Capable of an outstanding surface finish
	Excellent toughness
	Can be formed using a variety of processes
	Difficult to coldwork
More	**www.stelton.com**
Typical Applications	**Austenitic stainless steel is used in housewares, industrial piping, and architecture. Martensitic stainless steel is used to make knives and turbine blades. Ferritic stainless steel is corrosion resistant and is used for internal components in washing machines and boilers. Duplex stainless steel is highly corrosion-resistant and is used in aggressive environments**

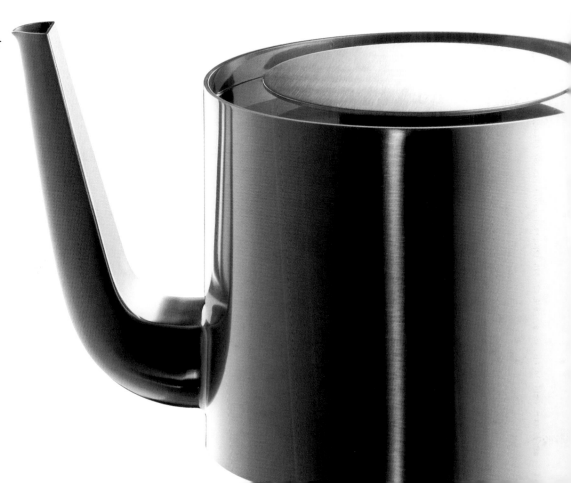

Musical metals

Brass is an alloy of copper (approximately 65 percent) and zinc (no more than 40 percent). The mechanical properties and characteristics of brass ↘ vary dramatically depending on the alloy and working method. There are around 70 different brass alloys, most of which can be grouped into major families. The most common are straight brasses, which have a zinc ↘ content of between five and 40 percent. Some of the brasses in this group include jewelry bronze, red brass, yellow brass, and gilding metal. Other main brass groups include leaded brass, casting brasses, and tin brasses. Some brasses are known as bronzes. Bronze is a copper ↘ alloy that has a main alloying element other than the usual zinc or nickel ↘.

These school bells by Swedish manufacturer Skultana Messingsbruk exploit the long musical tradition of brass. They have nearly 400 years of experience in forming handcrafted brass objects and a product range that reflects this history as well as contemporary, functional design.

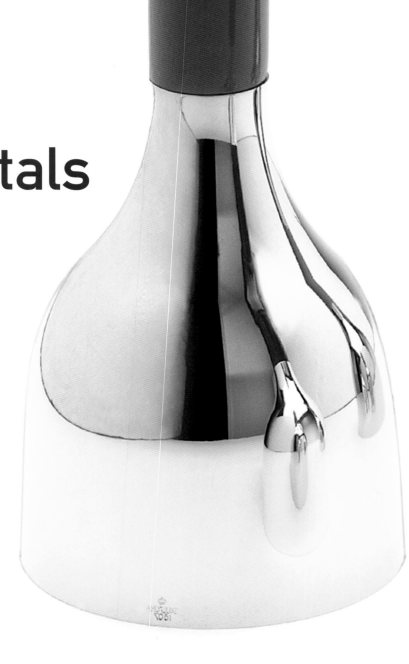

"Ring My Bell" school bells
Designer: Olof Kolte Design
Client: Skultuna Messingsbruk
Year of conception: 2001

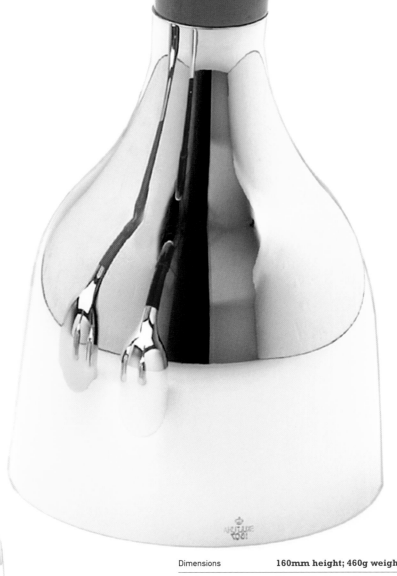

Dimensions	**160mm height; 460g weight**
Key Features	**Versatility in production**
	Recyclable
	Good machinability
	Good corrosion-resistance
	Good hotworking properties
	Good combination of strength and ductility
More	**www.brass.org**
	www.skultuna.com
	www.olofkoltedesign.com
Typical Applications	**A variety of brass alloys are used in a large number of applications including electric plugs, lightbulb fittings, precision medical instruments, cable glands, bearings, gearwheels, household and plumbing fittings, and aircraft, train, and car components**

more: Brass 025, 054–055, 090–091 Copper 014, 022–023, 025–027, 040, 090–091 Musical instruments 054–055, 090–091 Nickel 030, 041, 046–047, 062–063, 090–091, 104 Zinc 025, 034–035, 090–091, 126–127, 134–135

022

Soft and precious

This soft, yellow, precious metal has one of the richest symbolic and economic values of any material anywhere. Gold ↘ is one of the seven metals of antiquity, and has been crafted since 6,000BC. Together with six other metals—copper ↘, silver ↘, lead, tin, iron ↘, and mercury—gold has helped to build our civilization.

Apart from being extremely soft and easy to work in its pure form—a gram of gold can be worked into a leaf covering $0.6m^2$—its main distinguishing feature is that it is one of the rarest metals on earth. This has elevated it to superstardom as one of the richest metals available in terms of its associations, rituals, and symbolism, and as a display of status and wealth. In ancient times, it was owned only by the rich, and today it retains this stature as a precious metal ↘, a luxury possession for relatively few.

The purity of gold is measured by the carat. Pure gold is 24 carat, 18 carat refers to a purity, which is 18 parts out of 24. The term carat was an ancient Middle Eastern unit of weight that was derived from the carob seed. In 1999 the World Gold Council estimated that all the gold which had been mined so far could create a cube $19.35m^3$, or enough to fill 125 buses. Today most of the world's gold reserves belong to the USA.

Dimensions	**70mm diameter**
Key Features	**Extremely malleable**
	Corrosion-resistant
	Tarnish-resistant
	Bio-compatible
	High thermal conductivity
	High electrical conductivity
More	**www.gold.org**
Typical Applications	**Apart from jewelry and surface decoration, gold is used as an alloy in dentistry for restorations. The electronics industry uses gold-plated contacts and connectors in applications where silver and copper are not as tarnish-resistant. It is also used in bio-medical devices and nanotechnology, which exploit its corrosion-resistance, and as a coating for glazing to reduce heat transmission**

18ct gold bangles
Designer: Marlene McKibbin
Self-initiated project
Date: 2001

LINDBERG glasses frames
Designer: LINDBERG
Date: 1995

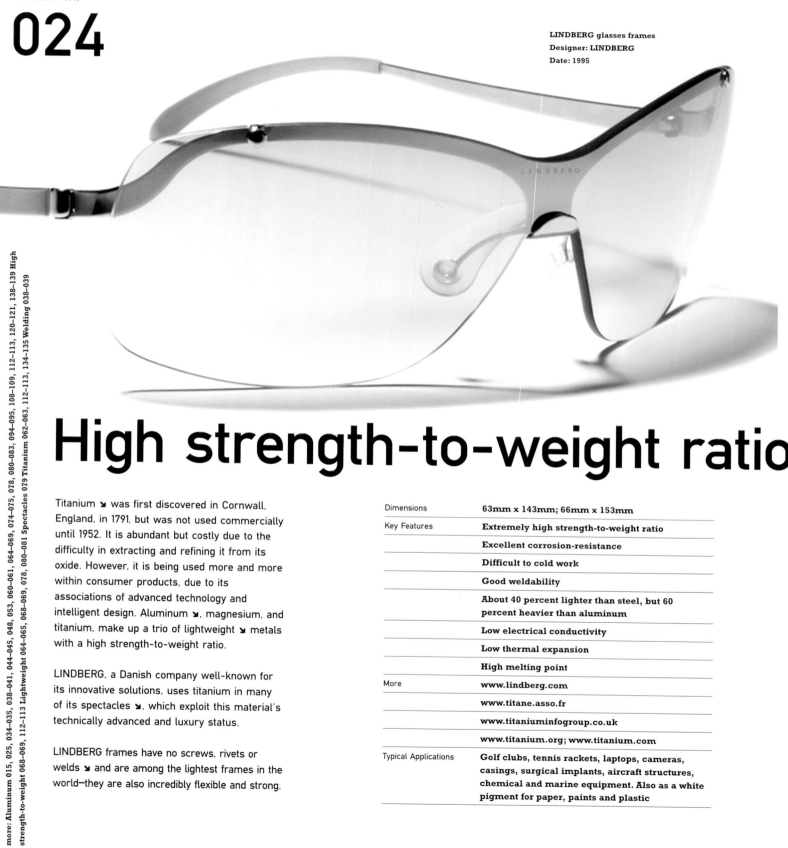

High strength-to-weight ratio

Titanium ⬎ was first discovered in Cornwall, England, in 1791, but was not used commercially until 1952. It is abundant but costly due to the difficulty in extracting and refining it from its oxide. However, it is being used more and more within consumer products, due to its associations of advanced technology and intelligent design. Aluminum ⬎, magnesium, and titanium, make up a trio of lightweight ⬎ metals with a high strength-to-weight ratio.

LINDBERG, a Danish company well-known for its innovative solutions, uses titanium in many of its spectacles ⬎, which exploit this material's technically advanced and luxury status.

LINDBERG frames have no screws, rivets or welds ⬎ and are among the lightest frames in the world—they are also incredibly flexible and strong.

Dimensions	63mm x 143mm; 66mm x 153mm
Key Features	Extremely high strength-to-weight ratio
	Excellent corrosion-resistance
	Difficult to cold work
	Good weldability
	About 40 percent lighter than steel, but 60 percent heavier than aluminum
	Low electrical conductivity
	Low thermal expansion
	High melting point
More	www.lindberg.com
	www.titane.asso.fr
	www.titaniuminfogroup.co.uk
	www.titanium.org; www.titanium.com
Typical Applications	Golf clubs, tennis rackets, laptops, cameras, casings, surgical implants, aircraft structures, chemical and marine equipment. Also as a white pigment for paper, paints and plastic

Zinc ⬎, a silvery, blue-gray metal, is a highly valued material. It is the third most used non-ferrous metal after aluminum ⬎ and copper ⬎. According to the U.S. Bureau of Mines the average person uses 331 kg of zinc in his or her lifetime. Its low melting point makes it an ideal material for casting ⬎, and zinc castings are very common: under the skin of door handles, taps, and electronic components. Its high resistance to corrosion explains its primary use as a partner to steel for galvanizing. Another major use of zinc is as an alloy with copper for forming brass ⬎. But its corrosion-resistance is not just exploited for steel—it also supports our immune system.

730 lbs in a lifetime

Dimensions	**122mm overall length**
Key Features	**Excellent castability**
	Excellent corrosion-resistance
	High strength and hardness
	Cheap raw material
	Low melting point and creep-resistance
	Alloys well with other metals
	Hygienic
	Brittle at ordinary temperatures
	Malleable at about 100°C (212°F)
More	**www.iza.com**
	www.zinc.org
Typical Applications	**Components for electronic products. As an alloy for bronze, and for bar tops which exploit its hygienic non-corrosive qualities. Also for roofing, photo-engraving plates, mobile phone antennae, and shutter mechanisms in cameras**

Gilette Mac3
Date: 1998

026

Behind the scenes

Dimensions	287mm high
Key Features	Outstanding heat and electricity conductor
	High sensitivity to light
	High optical reflection
	Malleable
	Corrosion-resistant
More	www.silversmithing.com
	www.silverinstitute.org
	www.georgjensen.com
Typical Applications	Jewelry, electronics, mirrors, heat-reflecting windows, prescription sunglasses, and for plating

Silver ⩗ is one of the seven metals of antiquity.
The ancient Greeks used silver to preserve wine
and other liquids. Today this third member of
the trio of precious metals ⩗ is used as much
as a backstage material within technology and
industry as it is for jewelry. When used for
jewelry, it is alloyed with copper ⩗ to produce
sterling silver, which is 92.5 percent silver and
7.5 percent copper.

However, its uses go far beyond body
adornment: silver provides us with some
surprisingly unique and outstanding properties.
It performs a range of functions within less
familiar industries. One of the outstanding
properties of this bright, white, non-tarnishing
metal, is its ability to reflect light. Mirrors,
windows for reflecting heat, and light-reacting
prescription sunglasses all utilize this feature of
silver. This unique ability to react with light also
accounts for its use within photography where it
forms latent images that can be developed later
to produce photographs.

"The Pregnant Duck"
992 pitcher
Designer: Henning Koppel
Manufacturer: Royal
Copenhagen A/S
Date: 1952

more: Copper 014, 020–023, 025, 040, 090–091 Precious metals 022–023, 028, 074–075, 092 Silver 014, 018–019, 084, 092, 132–133

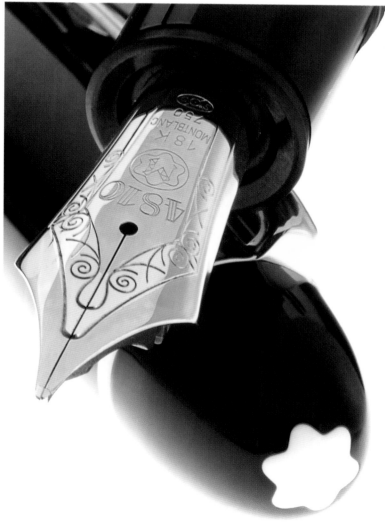

Dimensions	17mm length
Key Features	**Ductile**
	High density
	High melting point
	Achieves a high polish
	Excellent chemical resistance
	Excellent corrosion resistance
	Bio-compatible
More	**www.platinum.matthey.com**
	www.platinuminfo.net
	www.preciousplatinum.com
Typical Applications	**Jewelry, catalytic converters, fountain pens, aircraft spark plugs, as an alloy for coating shaving blades; electrical contacts and resistance wire, coatings, dental restoration, and computer hard disks to enhance magnetic qualities**

Platinum is a hard, white, ductile material. It is part of the precious metals ↘ group which includes palladium, iridium, rhodium, ruthenium, and osmium. Its ductility means that one gram can be formed into a piece of wire 1.609km long. Its use in jewelry is due its density, hardness, strength, and oxidation resistance. During World War II, platinum was declared a strategic material for use in armaments by the US government. It was not until relatively recently that its use in jewelry regained popularity. As with many metals, it has a biological function; one of the lesser known uses for this precious metal is in cancer treatment, where it can inhibit the growth of cancerous cells.

Partly-platinized Meisterstuck
149 fountain pen nib
Manufacturer: Mont-blanc
Date: 1994

more: Gold 014–015, 018–019, 022–023, 074–075, 128–129 Precious metals 022–023, 026–027, 074–075, 092

Soft and ductile

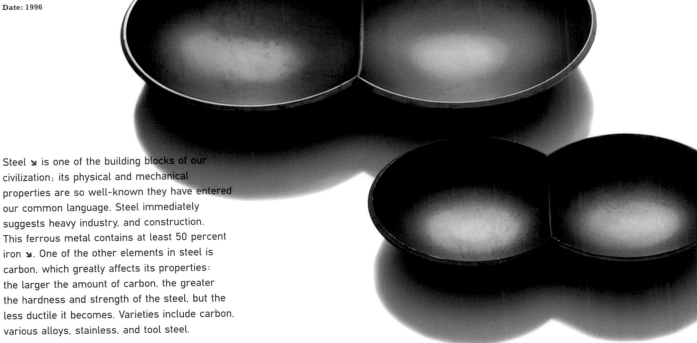

Sandblasted and painted steel
Malvinus multi-purpose trays
Designers: Alfred Haberli and
Christophe Marchand
Date: 1996

Steel ⟍ is one of the building blocks of our
civilization; its physical and mechanical
properties are so well-known they have entered
our common language. Steel immediately
suggests heavy industry, and construction.
This ferrous metal contains at least 50 percent
iron ⟍. One of the other elements in steel is
carbon, which greatly affects its properties:
the larger the amount of carbon, the greater
the hardness and strength of the steel, but the
less ductile it becomes. Varieties include carbon,
various alloys, stainless, and tool steel.

Most applications use carbon steel. Low carbon
steels can be easily formed into complex
shapes due to their ductility, and are used
for construction, and car body panels.
Medium carbon steels are also used in
construction and engineering. High carbon
steels are used for blades and knives due to
their hardness. Cold working steel increases
strength and decreases ductility, and like
aluminum, steel can be alloyed to enhance its
physical properties. These alloys include: lead,
which increases machineability; cobalt, which
increases hardness at high temperatures;
and nickel, which increases toughness.

Dimensions	480mm x 260mm x 65mm; 340mm x 190mm 65mm
Key Features	Strong and tough
	Easy to form
	Relatively inexpensive
	Needs little energy to recycle
Further Information	www.danesemilano.com
	www.corusgroup.com
Typical Applications	Construction, shipping, production tooling, bridges, cars, railways, furniture, household goods, and architecture

Building blocks

030

Revolution

Key Features	**Non-corrosive**
	Capable of an outstanding surface finish
	Excellent toughness
	Can be formed using a variety of processes
	Difficult to cold work
More	**www.bssa.org.uk**
Typical Applications	**Stainless steel has revolutionized industry. It is generally used in environments where there is the risk of corrosion and a need for heat-resistance. It is used for kitchen equipment, tableware, architectural applications, engine components, fasteners, tools, and dies**

Stainless steel spoon
Manufacturer: Alessi

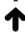

Stainless steel ⬎ has a mirrored surface which allows it to pick up reflections, shade, and light from its immediate environment. It really is a wonder material that has become so familiar that we now take it for granted.

Stainless steel is steel that is alloyed with chromium ⬎, nickel ⬎, and other elements. It owes its stainless properties to the chromium, which creates an invisible, tenacious, and self-healing chromium oxide film on its surface. Stainless steel is often referred to by the 18:10 mix of chromium and nickel respectively.

The introduction of stainless steel in the early part of the 20th century provided an opportunity for designers to exploit its corrosion-resistance and toughness, which led to the creation of new products for previously unexplored sectors. The results were revolutionary: for example, within the medical industry, where sterile, reusable equipment became available for the first time.

**Well Tempered Chair (four
die-cut tempered stainless
steel sheets)**
Designer: Ron Arad
Manufacturer: Vitra
International, Switzerland
Date: 1986

Bouncy

Metals are either ferrous or non-ferrous.
Ferrous metals are usually at least 50 percent
iron ⬎. It is in this family that steels exist,
making up most of its forms. Steel is one the
most versatile, widely used materials on the
planet. The list of product areas that use steel
is endless. Almost as endless are the varieties
of steels that can be produced and alloyed.
Steel ⬎ has become so much a part of our
existence that it is hard to imagine modern
life without it.

Dimensions	900mm high x 800mm wide x 800mm deep
Key Features	Tough
	Easy to form
	Strong
	Relatively inexpensive
	Needs little energy to recycle
More	www.ronarad.com
Typical Applications	Depending on the hardness of the steel and the amount of carbon they contain, carbon steels can fulfil an infinite range of uses, from cutting tools and knives to general construction and engineering, domestic products, furniture, car body panels, and packaging

↑

033 Production

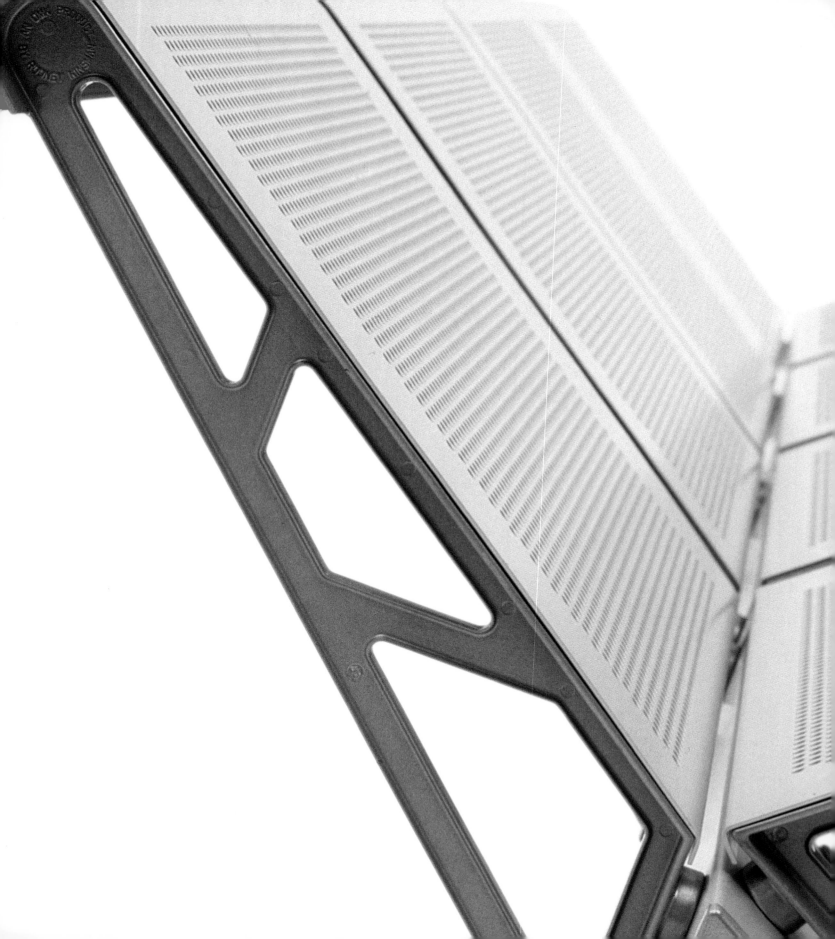

Component furniture

This simple seating design is based on three main elements: the seat, the support brackets, and a supporting triangular beam. The striking simplicity of this system is a great example of the possibilities of cast aluminum ↘, which exploits the design of a single structural element, which can then be reproduced in multiples. Rodney Kinsman says the design was inspired by an aircraft wing with a stressed skin structure.

The basic chair design can remain as just that, or it can act as a skeleton onto which other materials can be added. The surface can be easily washed down and has a maximum resistance to wear and tear. The simplicity of this set of components also allows for economical assembly.

Die-casting, sand-casting, and investment casting ↘ are all common methods used to produce metal components. Die-casting produces identical complex shapes ↘ and uses low temperature metals like aluminum, zinc ↘, and magnesium. Molten metal is forced under high pressure into a water-cooled metal die. When the component is solid, the pressure is released and the component ejected.

Dimensions	Seat 580mm wide; 2440mm wide overall
Key Features	Low unit cost
	Allows for production of thin walls
	High rate of production
	High tooling costs
	High tolerance
More	www.omkdesign.co.uk
	www.castmetalsfederation.com
Typical Applications	Camera bodies, and housings for electronic and engine components

Trax seating system
Designer: Rodney Kinsman
Manufacturer: OMK Design
Date: 1989

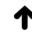

Stainless steel Rolls-Royce Spirit
of Ecstasy figurehead
Designer: Charles Robinson
Sykes
Manufacturer: Polycast Ltd.
Date: 1911

Lost wax

Dimensions	100mm high
Key Features	High degree of consistency and accuracy
	Can be used to form complex shapes
	Capable of an outstanding surface finish
	Low assembly costs as complex shapes can be created in a single cast
	Relatively low tooling costs
	Suitable for batch- or high-volume production
More	www.polycast.co.uk
	www.castmetalsfederation.com
	www.investmentcasting.org
	www.castmetals.com
Typical Applications	Ideal for creating complex components with lots of detail. Also used within sculpture including the Statue of Eros in Piccadilly Circus, London

Casting ↘ is one of the oldest methods of producing objects. The simple method of creating a form by pouring a liquid into a shaped hole has been applied and adapted to form endless glass, plastic, ceramic, and metal objects. One of the distinguishing features of investment casting, also known as the "lost wax" process, is its ability to produce metal components with complex shapes and undercuts. It also allows for cost-effective tooling ↘. Investment casting is one of the most accurate and consistent metal casting methods.

Stages of investment casting:
- An aluminum die is produced from which the wax patterns are made
- Wax patterns are then created by injecting wax into the die under pressure
- The patterns are gathered onto a wax runner or tree. Depending on its size, it is possible to have several hundred patterns on a tree, which can all be cast in one pour
- This tree is then dipped, or "invested", into a wet, ceramic-based slurry and coated with a fine, dry refractory. Once dry this coating process is repeated several times to create sufficient thickness. These layers need to be thick so that the structure can withstand the force of the molten metal
- Once the ceramic tree is dry it is placed in a steam oven. The wax is then melted out, leaving a series of cavities
- Molten metal is poured into the heated shells, which allows the metal to flow into the thin sections. This provides the fine detail
- After cooling, the ceramic shell is broken away from the now solid metal

more: Casting 025, 034–035, 044–045, 084, 105 Stainless steel 018–019, 030, 040–041, 046–047, 049, 050–052, 079, 096–097, 106–107, 114–115, 123–125, 132–133 Tooling 046–047

038

Production swapping

The Mirandolina stacking chair acknowledges the historical design of formed aluminum ↘ chairs, and extends the technology to include a less familiar production technique for this well-known product typology. It demonstrates the pressed technique ↘ of forming aluminum as well as extrusion ↘, a less common technique associated with producing chairs. This stacking chair starts off as a flat piece of extruded aluminum which is cut, drilled, and pressed into its three-dimensional form. The absence of nails, screws, glue, and welding ↘ is a further example of a flat material being taken from its horizontal plane to a useable rigid product.

The design of the chair ↘ has provided an opportunity for many design partnerships with aluminum, which exploit its ductile, lightweight, and corrosion-resistant properties.

Dimensions	**840mm high x 400mm wide x 530mm deep**
Key Features	**Sheets can be cut and formed in one process**
	High tooling costs
	Suitable for large components
	Suitable for a range of thicknesses
More	**www.zanotta.it**
	www.pietroarosio.it
Typical Applications	**Car body panels, metal casings for consumer products, biscuit tin lids, metal trays, and shelf brackets**

**Mirandolina stacking
chair in production
Manufacturer: Zanotta
Designer: Pietro Arosio
Date: 1992**

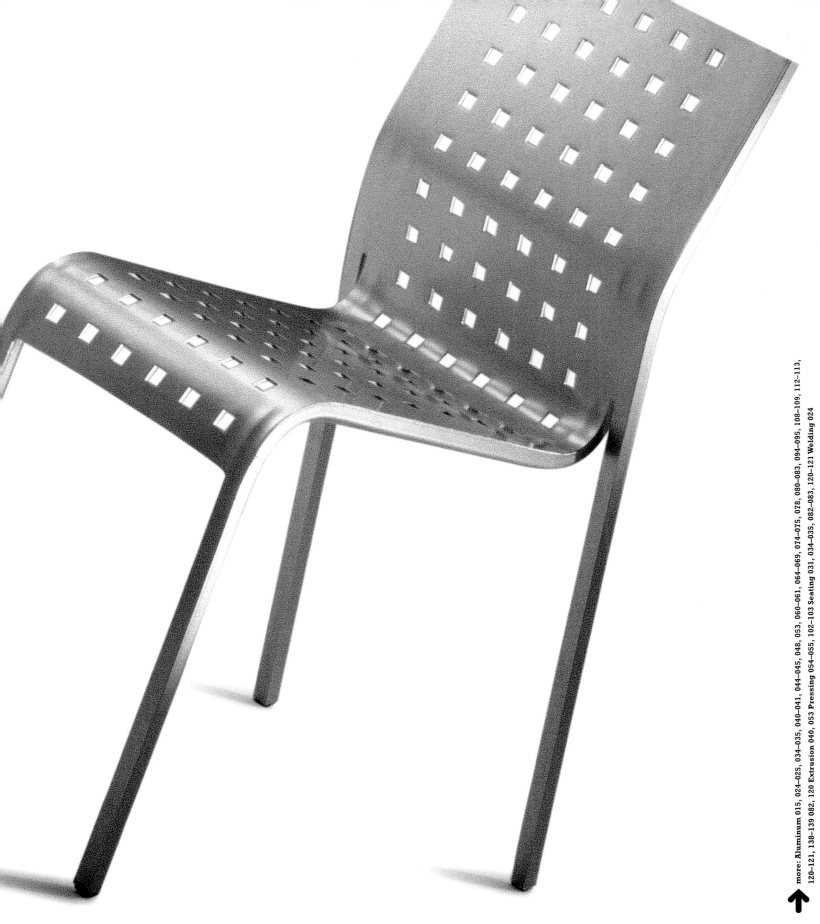

Profile designs

Extrusion is another common process applied to a range of metallic and non-metallic materials. The key aspect of this manufacturing process is that it allows you to produce a long strip of a profile, which can then be sliced into the desired lengths. Aluminum ↘ is a popular material for extrusions, as it has a low melting point. This is an essential characteristic of all extrusion ↘ materials, which include copper ↘, stainless steels ↘, medium and low carbon steels, and magnesium.

Extrusion is often combined with other methods, for example, extrusion blow-molding for plastics, or impact extrusion for metals. For standard metal extrusion however, there are two main forms: direct extrusion, where the metal is forced through a stationary die, allowing for longer lengths to be produced; and indirect extrusion, where the die compresses the metal producing less friction but shorter lengths.

Dimensions	**2250mm wide overall**
Key Features	**Allows for production of long, continuous lengths of the same shape**
	Allows for both solid and hollow shapes
	Low cost
	Can be applied to a range of materials
More	**www.aluminium-extrusion.hydro.com**
	www.omkdesign.co.uk
	www.aec.org
Typical Applications	**The process is universal and can be applied to most areas of design and engineering, including tubing, sheet materials, structures and body frames for motor vehicles, furniture, and components for consumer electronics**

Saville Bench
Designer: Rodney Kinsman
Manufacturer: OMK Design
Date: 1992

Non-rusting

At one time, stainless steel ⬎ was a revolutionary material due to its ability to remain rust-free. In the latter part of the 20th century, it became synonymous with clean, modern living. Stainless steel is an alloy that can be distinguished from steel by the inclusion of chromium ⬎, as well as small amounts of nickel ⬎, molybdenum ⬎, aluminum ⬎, and silicon.

Gijs Bakker, one of the founders of Droog Design, has designed a range of products combining glass with this steel/chromium mix, which are all characterized by a wavy surface. The soft forms of the range, combined with the unmistakable bright, polished surfaces, capture the beauty of this metal. The form and surface are in total harmony, creating an effect that closely echoes a drop of water on which the design is based.

These Flow products are manufactured by Keltum, part of Van Kempen and Begeer, a Dutch company with over 200 years' experience in producing traditional, high-quality ranges of metal tableware and gifts.

Flow Fruitbowl
Designer: Gijs Bakker
Manufacturer: Keltum
Date: 2000

Dimensions	**320mm diameter x 200mm high**
Key Features	**Non-corrosive**
	Capable of an outstanding surface finish
	Excellent toughness
	Can be formed using a variety of processes
Further Information	**www.gijsbakker.com**
	www.keltum.nl
Typical Applications	**Generally used in environments where there is a risk of corrosion and a need for heat resistance, including kitchen equipment, architectural applications, engine components and fasteners, tools and dies**

more: Aluminum 015, 024–025, 034–035, 038–039, 040, 044–045, 048, 053, 060–061, 064–069, 074–075, 078, 080–083, 094–095, 108–109, 112–113, 120–121, 138–139 Chromium 030, 123, 136–137 Molybdenum 088–089, 112–113 Nickel 020–021, 030, 046–047, 062–063, 090–091, 104 Stainless steel 018–019, 030, 036–037, 040, 046–047, 050–052, 079, 096–097, 106–107, 114–115, 123, 124–125, 132–133

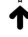

042

Revolution in a shape

Dimensions	65mm x 65mm x 109mm
Key Features	**Optimized shape and logistics**
	Convenient peelable end
	Less material used than a traditional can
	High print quality
	High tensile strength and formability
	Stackable design
	Food-safe
Further Information	**www.corusspace.com**
Typical Applications	**The coating of pure tin on steel plate creates a barrier against acids in food and provides a food-safe surface. Tin plate is also used for making toys, aerosols, cans, and batteries**

Everything in a supermarket is square: the trolleys, baskets, boxes, and even the lorries that transport the food. Kitchen cupboards are also square.

Corus ⬎ has revolutionized the food can ⬎ to fit and developed a flexible, square design. A square can offers advantages for everybody: the consumer who needs 20 percent less space in his cupboard at home, the retailer who uses 20 percent less shelf space in the supermarket, and the brand owner who gets brand differentiation through the outstanding shape. These cans also eliminate the ribs found on traditional cans offering a smooth, flat print surface.

In addition to these storage and transport benefits, the design offers flexibility during the heating process whilst retaining rigidity, has peel-off lids that enable consumers to open the can more easily, and weighs 15 percent less compared with the traditional food can, resulting in an extra environmental bonus.

Le Carré welded tinplate can body with easy peel off lid
Developed by: Corus Research,
Development, and Technology
Concept launched: 1999

more: Corus 070–071, 093, 124–125 Food and drink packaging 048, 053, 093

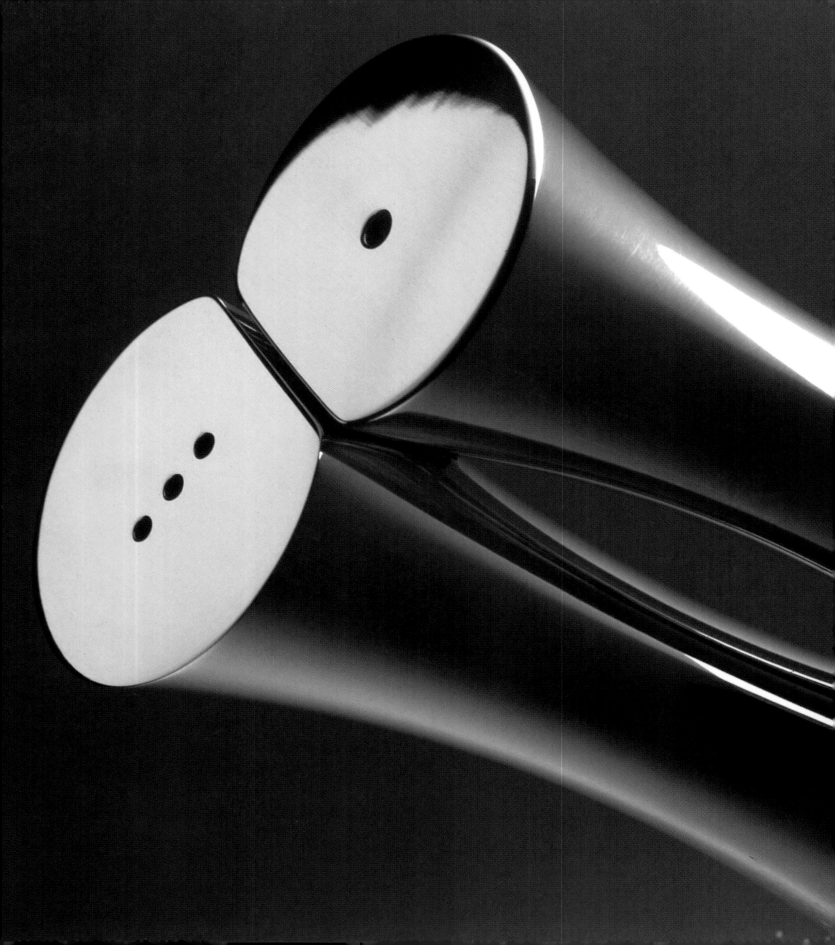

Evolution

Nambe products are made from state-of-the-art technology and basic sandcasting ↘ methods combined. These salt and pepper pots are made from an aerospace mixed aluminum ↘ alloy first produced in 1949. There is no silver, so it never tarnishes, and no lead, so it never cracks and is food safe. It stays polished with little upkeep and is 100 percent recyclable, as all metals separate at different temperatures.

"Each piece of Nambe is handled by 16 different people to produce the high-quality finished product. In 1994, the company introduced new technology in an attempt to reduce their costs and reach a greater market. But because Nambe was renowned for its handcrafted range, production methods had to combine the old and the new technologies. In the US, Nambe has revolutionized the tabletop industry and is now a market leader selling to Bloomingdales, Macy's, museum shops, and the finest tabletop retailers," says designer Karim Rashid.

Dimensions	**127.5mm high**
Key Features	**High strength-to-weight ratio**
	Easily forms alloys
	Excellent corrosion-resistance
	Excellent heat and electricity conductor
	Ductile
	Recyclable
More	**www.karimrashid.com**
	www.nambe.com
Typical Applications	**Aluminum alloy casting has applications in a huge range of products, from industrial components to tableware and giftware**

Kissing salt and pepper pots
Designer: Karim Rashid
Client: Nambe
Date: 1995

more: Aluminum 015, 024–025, 034–035, 038–041, 048, 053, 060–061, 064–069, 074–075, 078, 080–083, 094–095, 108–109, 112–113, 120–121, 138–139 Casting 025, 034–035, 036–037, 084, 105

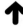

Flexible production

The starting point for this project was the idea of producing an inexpensive gift for lovers. The Adam & Eve keyrings, which slot together, are packaged in a glass chemistry bottle. The packaging is not only an intrinsic part of the narrative—i.e. the chemistry of lovers—but it can also be recycled. The design is based on male and female lavatory symbols with two "carefully placed" slots which allow the keyrings to come together at any time. Adam & Steve and Anna & Eve keyrings are also available.

"The keyrings are made by laser cutting—a process that needs a relatively small amount of initial tooling ↘ investment and offers a flexible production process. You can use laser cutting ↘ to make 10 or a million pieces. It's also a good method of cutting out complex or intricate shapes ↘. Originally, I wanted to use stainless steel ↘ but it proved to be cheaper to use plain steel and electroplate it with nickel ↘. Nickel provides a good resistance to tarnishing and corrosion maintaining that bright shiny surface which actually can also be applied to plastics," says designer Ben Panayi.

Dimensions	46mm x 32mm
Key Features	**Flexible production**
	No post-production finishing
	Intricate shapes can be cut
	Suitable for a range of materials
More	**b.panayi@blueyonder.co.uk**
Typical Applications	**Intricate and fine patterns can be laser cut into many flat materials. It is impossible to limit the use of laser cutting to a specific group of products. It is used to cut a diverse range of materials—from plastic and ceramics to wood and glass—within many different engineering and domestic applications**

Adam & Eve Keyrings
Designer: Ben Panayi
Manufacturer: Purves & Purves
Date: 1998

more: Laser cutting 052, 086–087, 102–103 Nickel 020–021, 030, 041, 062–063, 090–091, 104 Shapes 016–017, 034–035, 036–037, 050–051, 084 Stainless steel 018–019, 030, 036–037, 040–041, 049–052, 079, 096–097, 106–107, 114–115, 123–125, 132–133 Tooling 036–037

048

Fracture

Dimensions	54mm average diameter
Key Features	**Automated production**
	Large tooling costs
More	**www.rexam.com**
Typical Applications	**Metal pressing can be used for low-batch production as well as highly automated, high-volume production. Its applications are far reaching, from car body panels to ashtrays**

According to Rexam, a leading supplier of beverage cans ⬐, 210 billion canned drinks are consumed worldwide every year. Every time someone opens a can, they are using some of the most advanced packaging engineering ever developed. This mechanical wizardry means that the disposable ringpull mechanism works almost without fail.

The satisfying click of pulling the ring, followed by the fracturing of the metal and the "pssst" sound of the gas escaping from the can as the metal is sheared, creates the perfect opening from which to drink with a safe, rounded edge. Modern drinks cans are highly sophisticated, tamperproof, and airtight. The almost 100 percent reliable ring pulls are created by first stamping a coil of aluminum ⬐. Initially these are just round disks with no tab. A sealant is then applied on the underside of the disk, which acts as a seal once the can is full. The tabs are separately produced from a strip, and then attached to each can.

Aluminum ringpulls

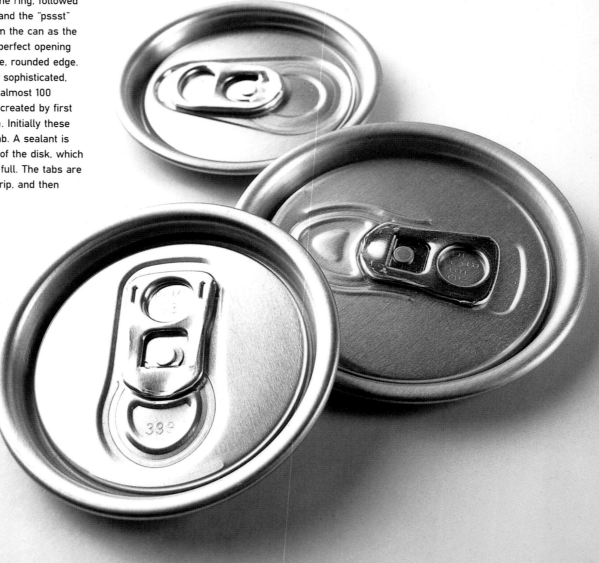

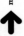

Inflatable steel

Material culture is littered with examples of materials that break with convention. That is to say, they are bent, formed, twisted, and heated into forms that contradict the preconceived nature of their physical qualities. They offer unexpected shapes that you might normally expect of another material. These pieces by designer Stephen Newby boast that surprising quality—the result of inflating a metal.

These soft pillow shapes are in stark contrast to the tough quality of the steel they are made from. The process, which has a patent pending, involves inflating the stainless steel ⬎ without molds. Each inflated piece responds in a different way, resulting in a unique design. The company produces a range of architectural and interior products where the material takes on a new language—not hard and rigid as you might expect, but much softer and more flexible, like a normal pillow.

Dimensions	$180mm^2$ x 50mm deep
Key Features	Unique processing method for metals
	Can be applied to a range of sizes (limited by sheet size only)
	One-off or batch-production
	Limitless shaping possibilities
Further Information	www.fullblownmetals.com
Typical Applications	Architectural, interiors, domestic accessories, furniture, and tableware

Plug container in polished
stainless steel
Designer: Stephen Newby
Date: 2002

050

The manufacture of components from powders exists in many polymer and ceramic industries, but less known is that metal products can be formed in the same way. Metal injection molding (MIM) is a way of producing complex shapes ↘ in large numbers from high-temperature materials like tool steel and stainless steel ↘, that are not suitable for die-casting.

This process is only about 30 years old and has been limited by a lack of suitable powders that can be used as the starting point. MIM involves more processes than plastic injection molding, and the various companies developing the technology each have their own unique binder systems that are mixed with the metal powders to produce the molding compound. Having molded the shapes, the binder is no longer needed and thus removed from the metal particles. What is left is then sintered. Through this process of sintering (a heating process where all the metal particles are welded together), the component shrinks by about 20 percent.

Very few companies are involved in this process. In recognition of their innovation in the MIM process, the UK manufacturer, Metal Injection Mouldings, was awarded a Millennium Products status from the British Design Council in 1999.

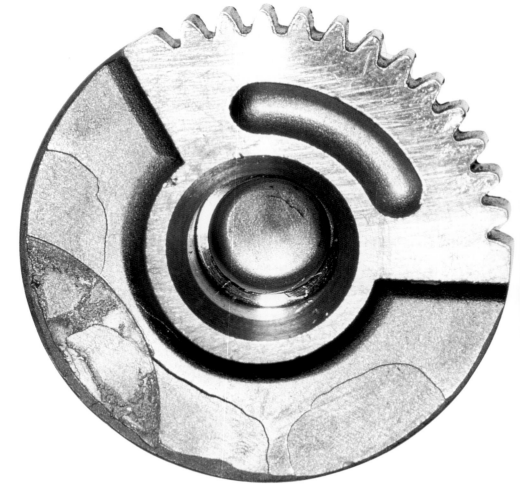

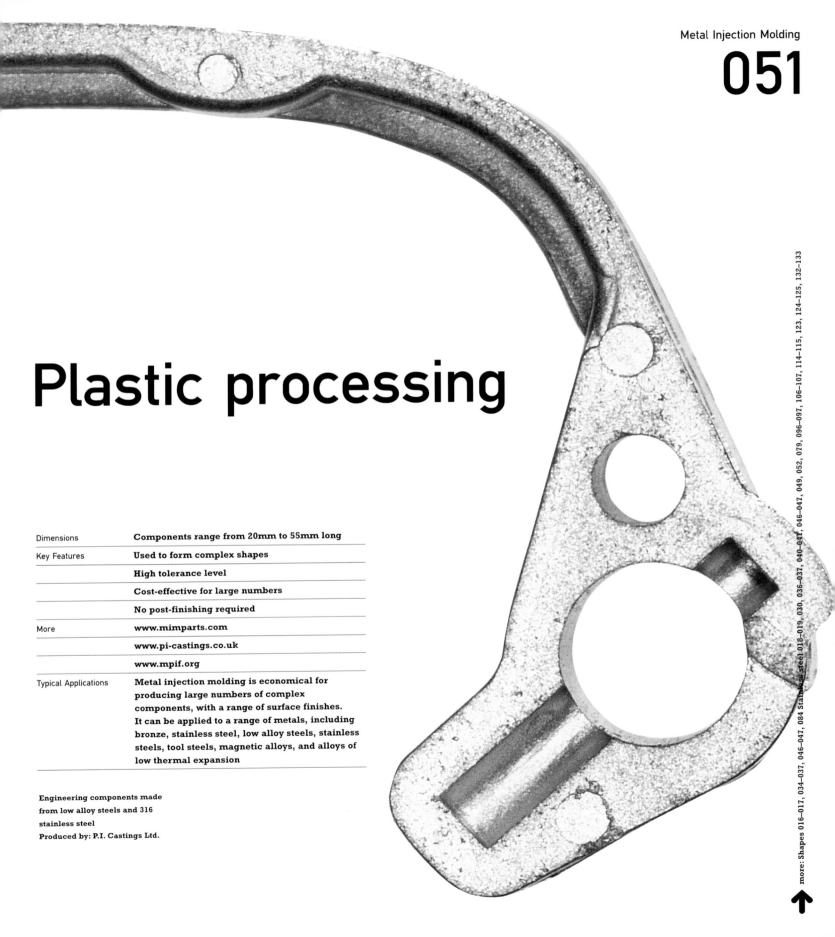

Plastic processing

Dimensions	**Components range from 20mm to 55mm long**
Key Features	**Used to form complex shapes**
	High tolerance level
	Cost-effective for large numbers
	No post-finishing required
More	**www.mimparts.com**
	www.pi-castings.co.uk
	www.mpif.org
Typical Applications	**Metal injection molding is economical for producing large numbers of complex components, with a range of surface finishes. It can be applied to a range of metals, including bronze, stainless steel, low alloy steels, stainless steels, tool steels, magnetic alloys, and alloys of low thermal expansion**

Engineering components made from low alloy steels and 316 stainless steel
Produced by: P.I. Castings Ltd.

more: Shapes 016–017, 034–037, 046–047, 084 Stainless steel 018–019, 030, 036–037, 040–041, 046–047, 049, 052, 079, 096–097, 106–107, 114–115, 123, 124–125, 132–133

Chemical milling

Dimensions	80mm² x 80mm thickness unfolded; 0.15mm stainless steel
Key Features	High tolerance
	Thinnest bar is 0.2mm
	Thinnest line is 0.04mm
	Any flat shape can be used
	One-offs or mass production
	Low-cost tooling
	Suitable for photographic images
	Considerably cheaper than laser cutting
Further Information	www.mikroworld.com
	www.npw.co.uk
Typical Applications	Screens for printing solder tracks onto PC boards within the electronics industry, industrial components, and flexible trigger devices for missiles (the fine trigger changes according to air pressure the closer it gets to its target)

Cutting and folding a flat sheet of material to form a product is a traditional design method. This process has the potential to create paper-thin, delicate, and intricate, yet rigid patterns ⩊ on the surface of the material.

Sam Buxton has created an alternative business card: "I originally used acid-etched, stainless steel cards for my business. I was interested in the idea of each card being something to keep on your desk. I also liked the idea of making miniature scenes from a flat sheet. A manufacturer saw the cards and asked me to make a series that could be mass-produced. Stainless steel ⩊ was the best material to use because it was rigid, held its shape, and, when combined with the technology, was a perfect way of realizing this piece of theater".

Sam draws the image on a CAD program, then sends it in digital format to the manufacturer. They then make a photographic screen, which is used to print an acid-resistant ink onto both sides of the steel because the acid will eat away at the metal from either side, reducing the time it needs to stay in the acid bath. It also means that patterns can be formed without cutting the steel all the way through. Acid-etching provides a much more cost-effective way of cutting intricate patterns in metals than processes like laser cutting ⩊.

Mikro Man House
Designer: Sam Buxton
Distributor: Worldwide
Date: 2003

Robust

The Sigg brand has achieved over 70 percent recognition in German-speaking countries, with its robust aluminum ↘ drinks bottle ↘ which has become a design icon without the appearance of being designed.

Impact extrusion ↘ is a cold process for forming ductile metals, which punches a slug of metal into a cavity at high-pressure. Production begins with an aluminum metal slug. A punch is brought down onto the slug, forcing the metal to flow upwards into the die cavity, creating a parallel-sided cylinder. A threaded ring provides the fixture for the cap to be screwed onto. The interior is sprayed with a foodsafe stove enamel, which resists the acid in fruit drinks. A powder coating is then applied to the outside of the bottle to give it its distinctive finish.

Action Bottle
Manufacturer: SIGG
Switzerland AG
Date: 2004 Collection

Dimensions	**240mm high x 70mm maximum diameter**
Key Features	**Requires no draft angle**
	Can tolerate varying wall thicknesses
	Rapid production
	Low unit cost
	Low tooling costs
More	**www.sigg.ch**
	www.metalimpact.com
Typical Applications	**Drinks cans, toothpaste tubes, nozzles for spray guns, cigar tubes, various hollow and solid engineering components**

more: Aluminum 015, 024–025, 034–035, 038–041, 044–045, 048, 060–061, 064–069, 074–075, 078, 080–083, 094–095, 108–109, 112–113, 120–121, 138–139 Extrusion 038–039, 040 Food and drink packaging 042–043, 048, 093

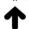

054

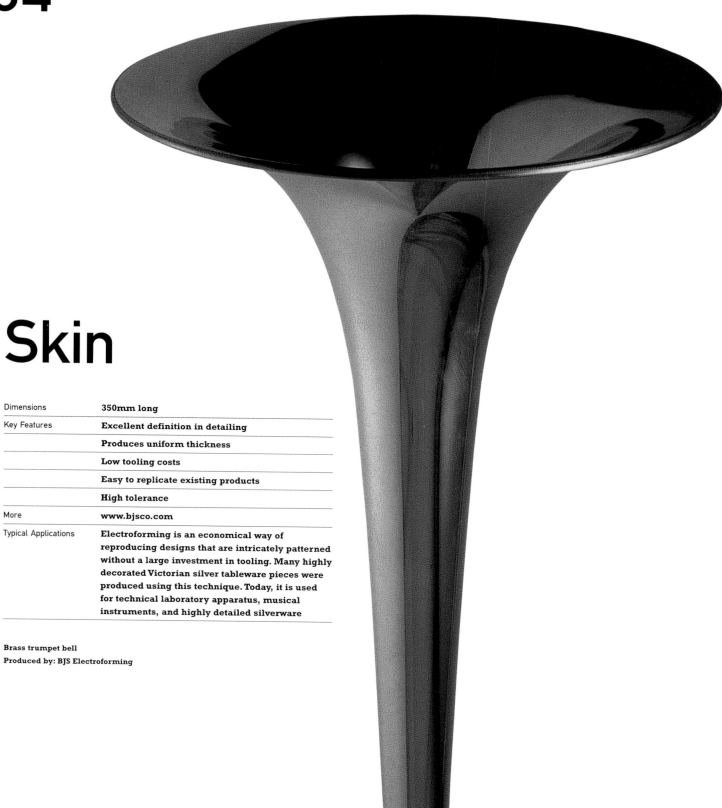

Skin

Dimensions	350mm long
Key Features	Excellent definition in detailing
	Produces uniform thickness
	Low tooling costs
	Easy to replicate existing products
	High tolerance
More	www.bjsco.com
Typical Applications	Electroforming is an economical way of reproducing designs that are intricately patterned without a large investment in tooling. Many highly decorated Victorian silver tableware pieces were produced using this technique. Today, it is used for technical laboratory apparatus, musical instruments, and highly detailed silverware

Brass trumpet bell
Produced by: BJS Electroforming

Need to replace one of your grandmother's silver plates, or perhaps produce your own intricately-patterned design in silver? Consider electroforming, a process that goes one step further than electroplating ⬎. Instead of producing a layer of only a few microns thick, electroforming builds up a skin of metal of even thickness which is then thick enough to be lifted off the mold.

The process electro-deposits metal onto molds or mandrels. When a sufficient build-up of metal is achieved, the component is separated from the mold. These molds can be made from any non-conductive material, which can be coated with conductive coating prior to plating. The cost of electroforming is based on the amount of metal used—i.e. the surface area of the mold and the thickness of the deposited metal.

With most other methods of manufacture, the material to be used is transformed from one state to another, but with electroforming a replica is created by the slow build-up of a skin over the mold. Intricate, flat, and three-dimensional patterns can easily be reproduced without expensive tooling. It is also unique in that it creates a uniform layer around the mold, unlike pressing ⬎, which stretches the material and creates an uneven thickness.

more: Brass 020–021, 025, 090–091 Electroplating 126–127, 128–129 Musical instruments 020–021, 090–091 Pressing 038–039, 102–103

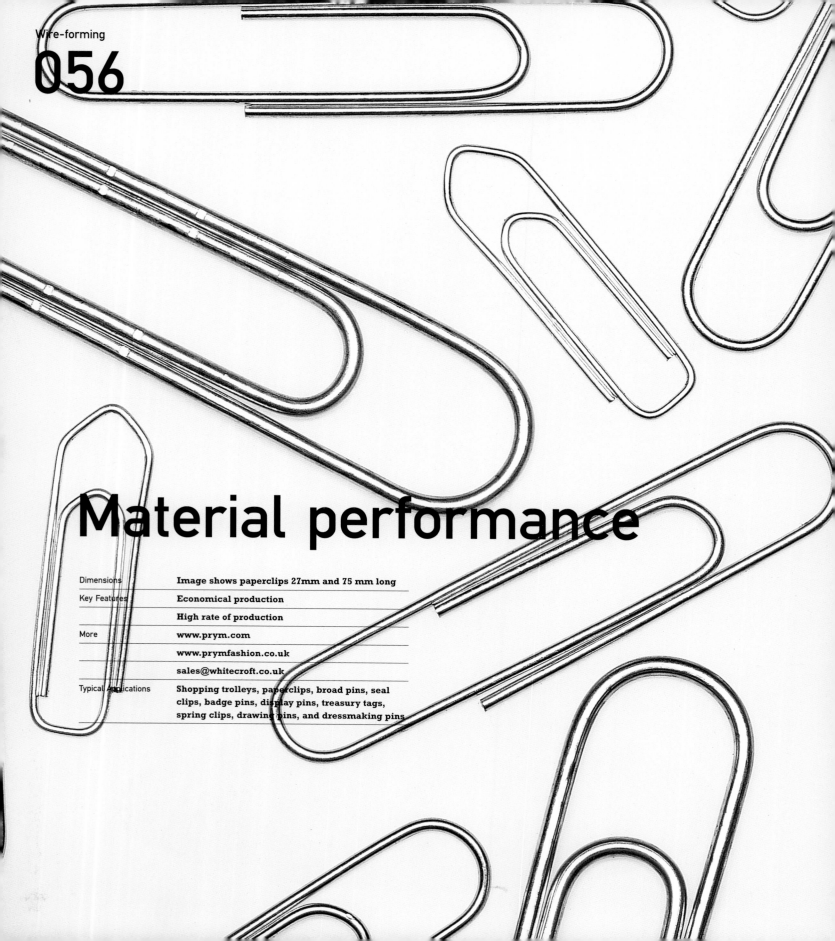

Material performance

Dimensions	Image shows paperclips 27mm and 75 mm long
Key Features	Economical production
	High rate of production
More	www.prym.com
	www.prymfashion.co.uk
	sales@whitecroft.co.uk
Typical Applications	Shopping trolleys, paperclips, broad pins, seal clips, badge pins, display pins, treasury tags, spring clips, drawing pins, and dressmaking pins

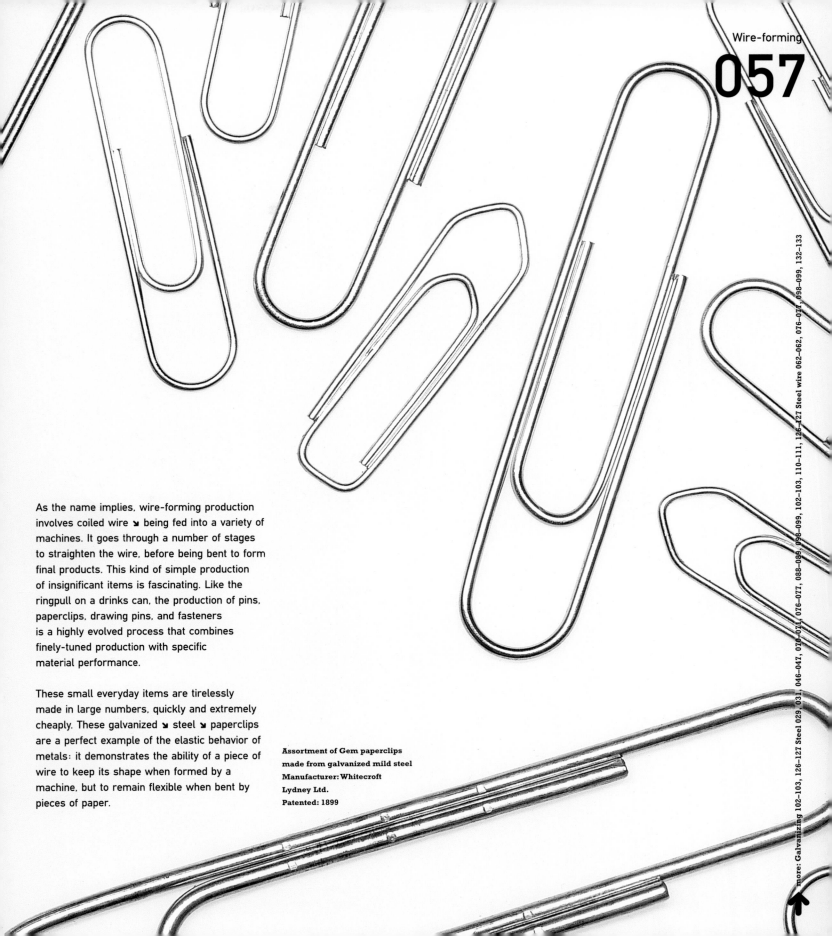

As the name implies, wire-forming production involves coiled wire ⬎ being fed into a variety of machines. It goes through a number of stages to straighten the wire, before being bent to form final products. This kind of simple production of insignificant items is fascinating. Like the ringpull on a drinks can, the production of pins, paperclips, drawing pins, and fasteners is a highly evolved process that combines finely-tuned production with specific material performance.

These small everyday items are tirelessly made in large numbers, quickly and extremely cheaply. These galvanized ⬎ steel ⬎ paperclips are a perfect example of the elastic behavior of metals: it demonstrates the ability of a piece of wire to keep its shape when formed by a machine, but to remain flexible when bent by pieces of paper.

Assortment of Gem paperclips
made from galvanized mild steel
Manufacturer: Whitecroft
Lydney Ltd.
Patented: 1899

more: Galvanizing 102–103, 126–127 Steel 029, 031, 046–047, 076–077, 076–077, 088–089, 098–099, 102–103, 110–111, 126–127 Steel wire 062–062, 076–077, 098–099, 132–133

059 Semi-formed

Rigid origami

Twist it, paint it, wrap it, stick it and it will always hold its shape. Photographers and film studio technicians use this incredible material for reducing unwanted spill from light.
By folding and creasing this sheet material around lighting, they have more control over its effect. It also has the advantage of not burning under the intense heat of studio lights.

A sheet of BLACKWRAP feels like a cross between a thick aluminum ⬊ kitchen foil and paper. It is more rigid than foil and has a matte finish due to the black paint. It is an excellent material for simple forming with a unique tactile experience.

Sample of BLACKWRAP
Distributed in the US by Gam
Products Inc.

Dimensions	600mm x 7.5m; 300mm x 15m
Key Features	**Heat-resistant**
	Very pliable
	Keeps its shape
	Blocks light
More	www.lemark.co.uk
	www.gamonline.com
	www.allfoils.com
Typical Applications	**BLACKWRAP is good for masking light leaks in technical lighting applications such as film and photography studios. It is also used to black-out windows and conceal cabling**

Memory

Dimensions	Approximately 30mm long when unformed
Key Features	Shape-altering
	Available in a range of forms, shapes, and products
	Corrosion-resistant
	Bio-compatible
More	www.memory-metalle.de
	www.memry.com
	www.fraunhofer.de
	www.nidi.org
Typical Applications	Thermal memory effects are used in areas where movement needs to take place in a restricted space. Most applications are in engineering where it is used for tube-coupling in spacecrafts, actuators in a range of industrial applications, on/off switches, and thermostats

Welcome to the world of shape memory alloys. With these materials, you enter the arena of smart materials: those which respond to an external stimulus or, in less formal terms, that are worthy of their own magic show.

Imagine a straight strip ↘ of metal that, when heated, or has an electrical current passed through it, will transform itself into a paper clip, or a superelastic metal that can be twisted and bent and then relax and return to its original form. Collectively, these materials are known as shape memory alloys; materials that have been given a memory.

There are several varieties of shape memory alloys. Memory Metalle in Germany is a leading producer of these nickel-titanium ↘ metals. Thermal shape memory alloys ↘ respond to heat, transforming them from one shape to another, which the metal is programmed to remember. This transformation is fully reversible, allowing the alloy to return to its original shape if distorted. This means that you can bend and twist the metal, heat it, and watch it return to its original shape.

Nitinol thermal shape memory alloy paperclip
Producer: Memory-Metalle GmbH
First introduced: 1999

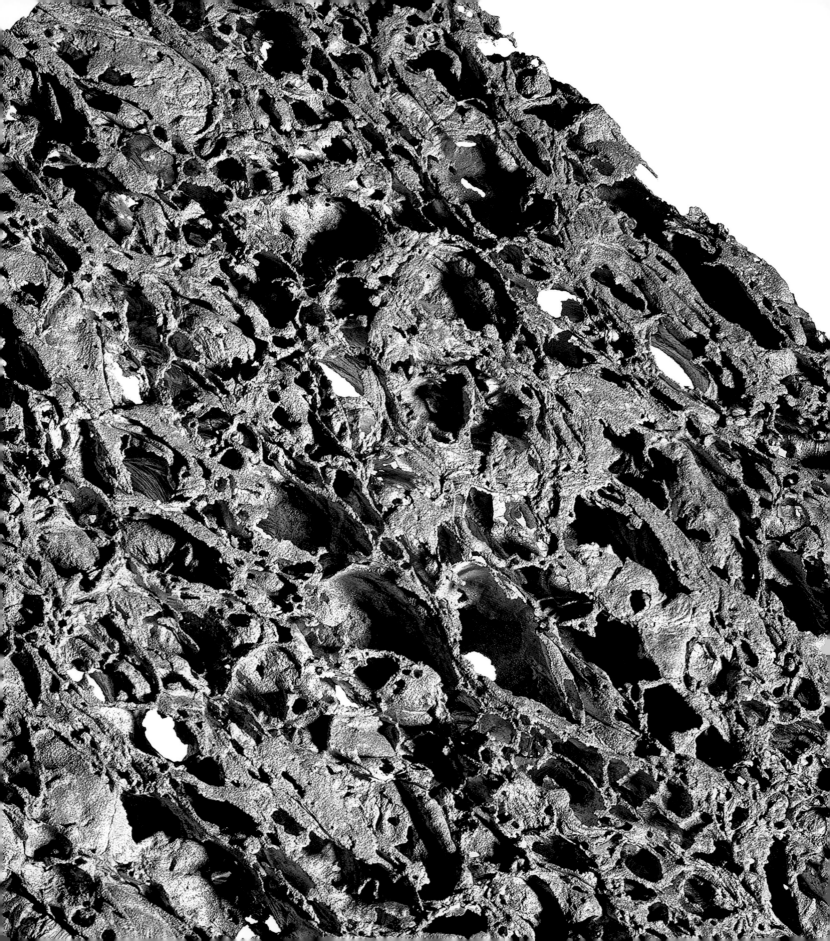

Dimensions	203mm length; 25mm thickness
Key Features	**Good insulation**
	High strength-to-weight ratio
	100 percent recyclable
	Highly distinctive, decorative surface
	Can be post-formed using heat
More	**www.alusion.com**
	www.cymat.com
Typical Applications	**Alusion is used in a variety of interior applications including flooring, interior accessories, signage, countertops, and lighting**

Glasslaminated small cell sample, Open cell basic, Natural basic small cell samples
Manufacturer: Alusion

Imagine a porous and lightweight ⬎ natural sponge, but instead of being soft and squashy as you would expect, it is rigid and hard, like an eroded, rough-textured piece of metallic rock, or even a metallic wasps' nest.

Alusion's stabilized aluminum ⬎ foam is different from other metallic foams: it is more rugged and does not have the regularity of sponge-like pores. The company uses a patented process to produce a range of sheet products that exploit the lightweight properties of open cells. Ceramic particles are added to an aluminum alloy to form the basic material. The foam is created when gas bubbles enter the molten material. The foam then collects on the surface. where it is continuously drawn off to form a sheet ⬎.

The sheets are available in two densities with different cell sizes and a range of finishes, including glass and resin. With a texture as rough as brick, and a surface that allows pockets of light to filter through, this is a unique material to add to the designer's palette of semi-formed sheet materials.

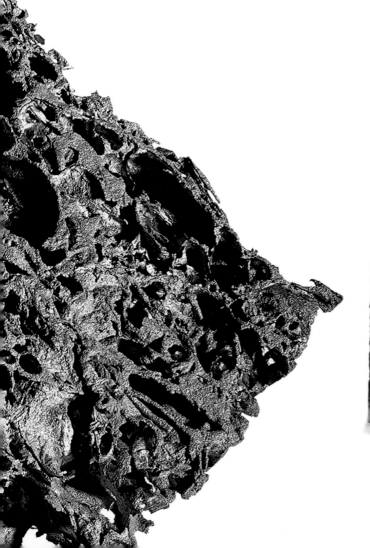

Designer holes

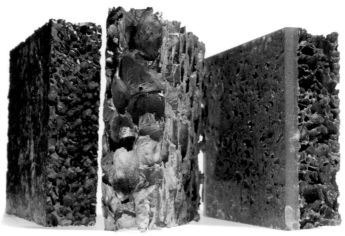

Sandwich

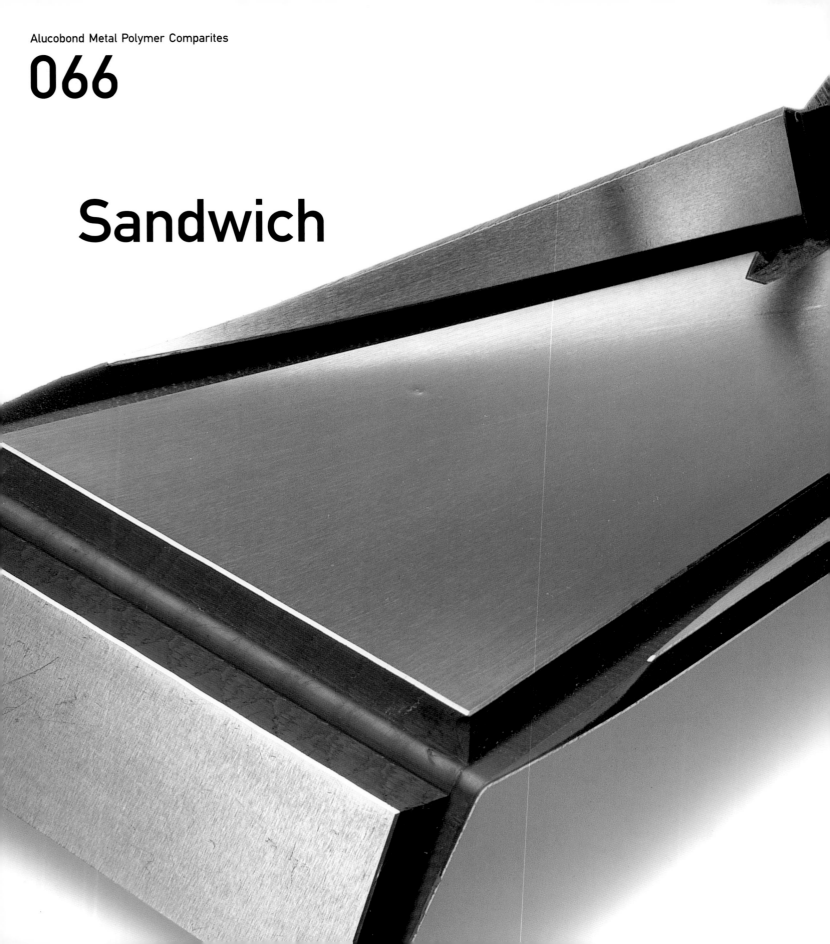

Dimensions	**4mm standard thickness**
Key Features	**Can be easily folded**
	Fire classification approved for most building applications
	Lightweight
	Rigid, flat surface
	Available in a range of colors
	Weather-resistant surface
	Recyclable
More	**www.alucobond.com**
Typical Applications	**Architectural facades, signage, furniture, architectural components, shelving, exhibition stands, shop interiors, roofs, interior cladding, and suitcases**

Alucobond sample
Produced by: Alusuisse Singen
GmbH

Imagine a sheet material ↘ with an aluminum ↘ coating that is folded easily, lightweight, and can be used to make rigid structures. Alucobond is a foldable, rigid, composite panel product consisting of a plastic core covered with an aluminum skin on both sides. It is one of those semi-formed materials that beg for new products and applications to be discovered by designers. Alucobond belongs to a family of sandwich materials produced by Alusuisse Singen GmbH, who manufacture a range of aluminum composite panel products.

First manufactured in 1969, Alucobond has been used predominantly within architectural and interior applications. One its best features is the ease with which it can be shaped using relatively simple industrial techniques. By routing a variety of grooves into the surface, the sheets can be folded or even bent to a radius. These versatile sheets can be cut, bent, folded, riveted, sheared, drilled, and glued, at the same time as being good for constructing rigid shapes and structures.

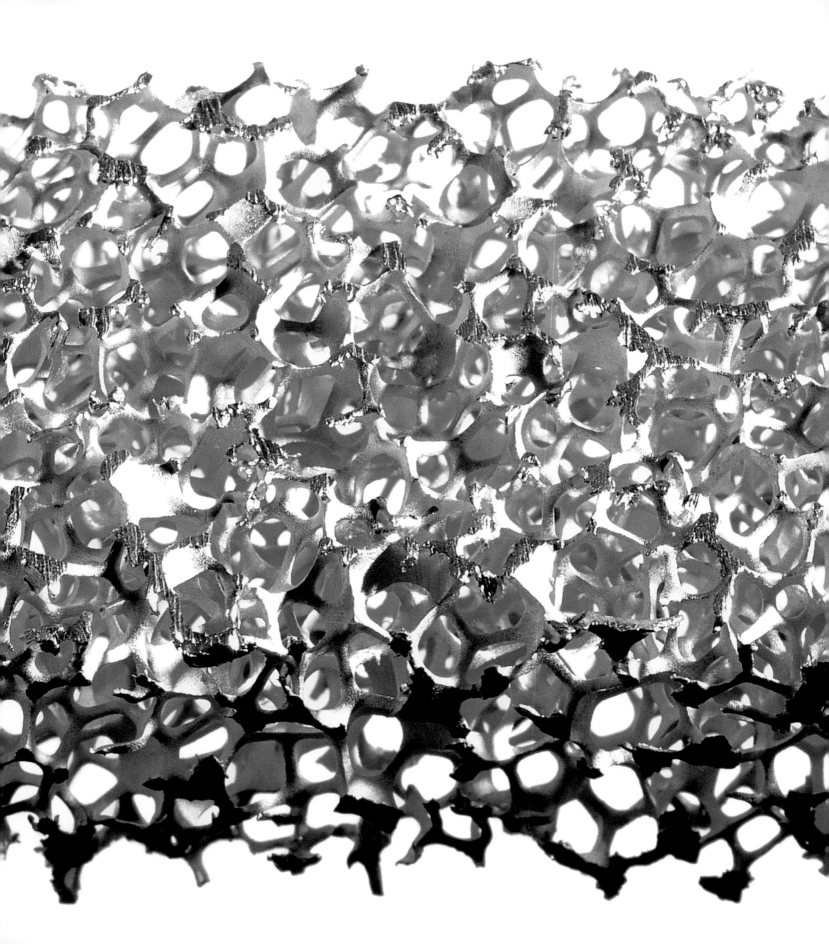

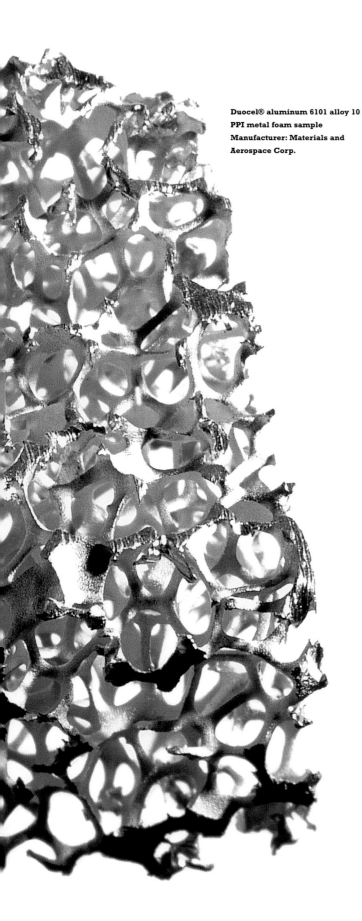

Duocel® aluminum 6101 alloy 10
PPI metal foam sample
Manufacturer: Materials and
Aerospace Corp.

Metal foam

There are some materials that need no
introduction to motivate designers, like sheets of
translucent polypropylene, for example. Coveted
samples of these inspirational materials are
often kept close at hand by designers who bide
their time, waiting for just the right commission
in order to fully exploit their appealing qualities.
These are the kind of semi-formed materials
that designers often discover have been used in
industrial applications for years.

This lightweight ⬊ aluminum ⬊ alloy foam
combines qualities you would normally find in a
natural form using metallic alloys. These metals
are highly valued for their mechanical
properties: the large surface area, their high
strength-to-weight ratio ⬊, and so on. Within
these high-performance materials lies a
network of air pockets: an interconnecting,
three-dimensional mesh that is as intriguing
as a natural sponge or a piece of coral.

Dimensions	6–8 percent density; 90mm x 40mm
Key Features	Stiff
	High strength-to-weight ratio for superior performance
	Less than 10 percent of the weight of solid aluminum
	Can be cut, turned, milled, and ground
	Can accept a range of finishes
More	www.ergaerospace.com
Typical Applications	Heat sinks for electronic components, aircraft wing structures, energy absorbers for car bumpers, flow straightness in wind tunnels, structures for high-strength panels, heat shields for aircraft exhausts, jet engine silencers, energy absorption for blast shock waves, and structural elements for satellites

more: Aluminum 015, 024–025, 034–035, 038–039, 040–041, 044–045, 048, 053, 060–061, 064–067, 074–075, 078, 080–083, 094–095, 108–109, 112–113, 120–121, 138–139 High strength-to-weight 024, 112–113 Lightweight 024, 064–065, 078, 080–081

070

Paper-thin

This is steel ↘ that you can fold like paper, bend, join, print, and color. You can create, enhance, experiment, and, most of all, surprise with this innovative new material by Corus Packaging Plus.

Proflex is a new ultra-thin steel that can be used for new and innovative applications. It means that designers can create packaging that is structurally different due to its formable properties. Proflex is an unconventional ultra-thin steel with properties that make it unique and environmentally friendly. It is visually striking due to its excellent capacity to hold high definition print.

Proflex is available in a variety of colors due to the different polymer coatings that can be used. This, combined with the range of grades available—from hard to soft—makes Proflex conducive to all shaping and decorative techniques such as embossing, gluing, heat sealing, bending etc., to create innovative packaging designs.

Dimensions	750–950 mm wide; 80–120 microns thick
Key Features	**Ultra thin**
	Flexible
	Ductile
	Formable
	Tactile
	Available in a variety of colors and grades
	100% recyclable
More	**www.corusspace.com**
Typical Applications	**The main areas of design that currently exploit this material are within the packaging industry. Corus Packaging Plus encourages designers to explore its potential in packaging and other new applications**

Samples of ultra-thin polymer-coated material by film application or direct extrusion Manufacturer: Corus Packaging Plus Date: In development

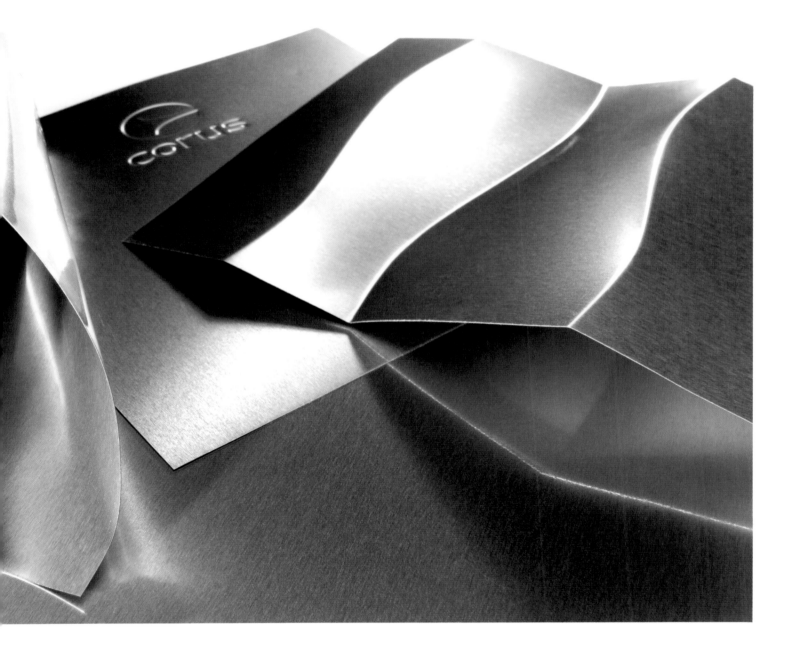

073 Objects

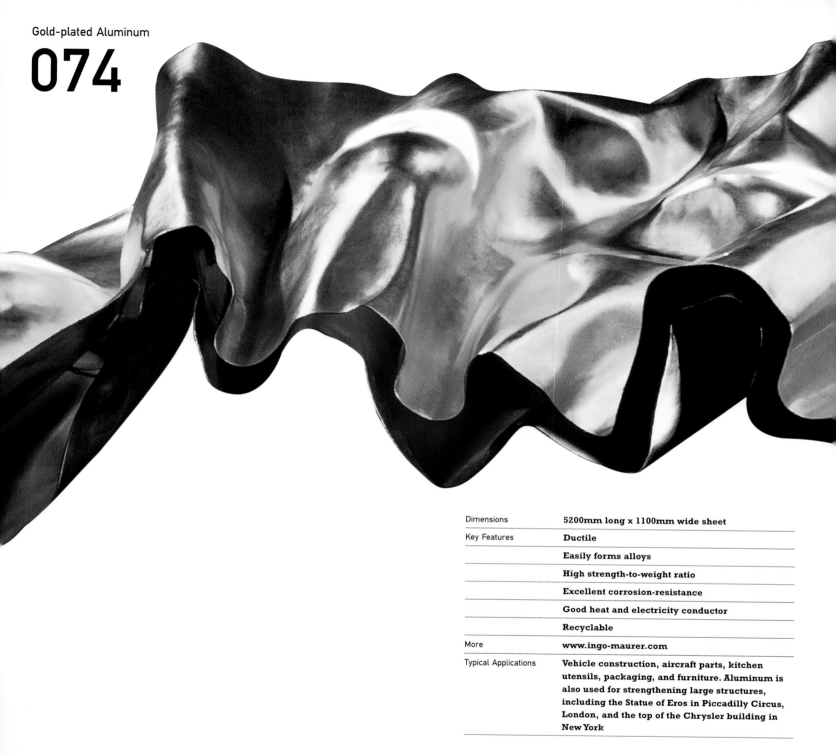

Dimensions	**5200mm long x 1100mm wide sheet**
Key Features	**Ductile**
	Easily forms alloys
	High strength-to-weight ratio
	Excellent corrosion-resistance
	Good heat and electricity conductor
	Recyclable
More	**www.ingo-maurer.com**
Typical Applications	**Vehicle construction, aircraft parts, kitchen utensils, packaging, and furniture. Aluminum is also used for strengthening large structures, including the Statue of Eros in Piccadilly Circus, London, and the top of the Chrysler building in New York**

Paragaudi Light
Designer: Ingo Maurer
First produced: 1997

Poetry of materials

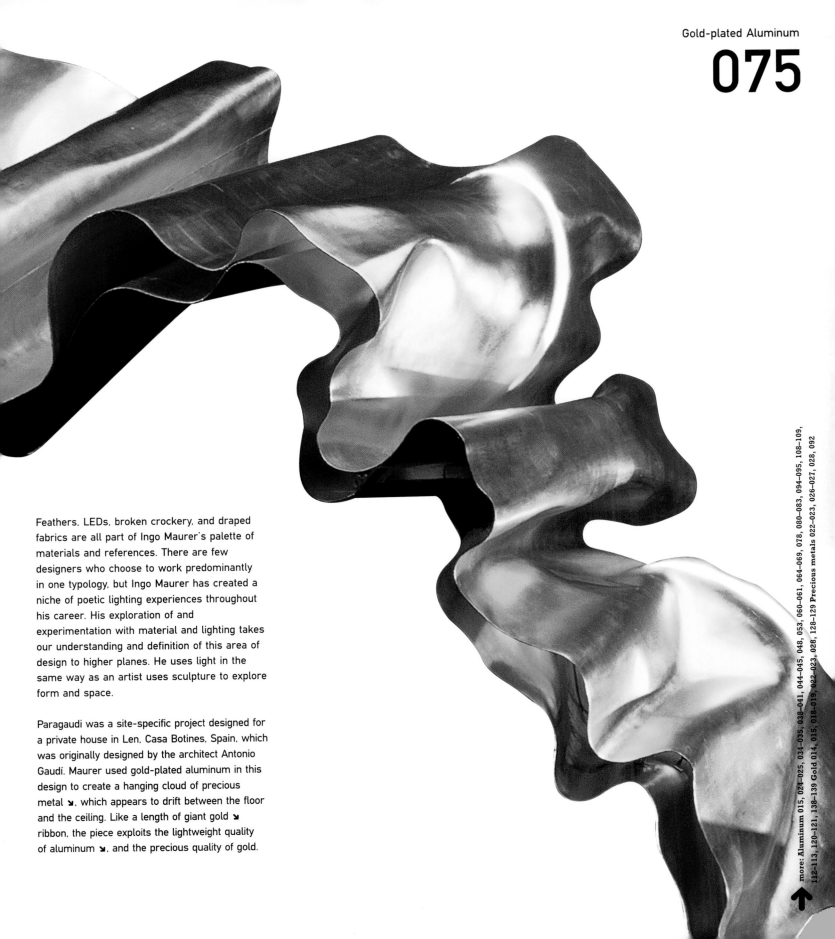

Feathers, LEDs, broken crockery, and draped
fabrics are all part of Ingo Maurer's palette of
materials and references. There are few
designers who choose to work predominantly
in one typology, but Ingo Maurer has created a
niche of poetic lighting experiences throughout
his career. His exploration of and
experimentation with material and lighting takes
our understanding and definition of this area of
design to higher planes. He uses light in the
same way as an artist uses sculpture to explore
form and space.

Paragaudi was a site-specific project designed for
a private house in Len, Casa Botines, Spain, which
was originally designed by the architect Antonio
Gaudí. Maurer used gold-plated aluminum in this
design to create a hanging cloud of precious
metal ⬊, which appears to drift between the floor
and the ceiling. Like a length of giant gold ⬊
ribbon, the piece exploits the lightweight quality
of aluminum ⬊, and the precious quality of gold.

more: Aluminum 015, 024–025, 034–035, 038–041, 044–045, 048, 053, 060–061, 064–069, 078, 080–083, 094–095, 108–109, 112–113, 120–121, 138–139 Gold 014, 015, 018–019, 022–023, 028, 128–129 Precious metals 022–023, 026–027, 028, 092

Energy storage

Dimensions	500mm diameter in its enlarged state
Key Features	High degree of flexibility
	Fatigue-resistant
	Available in a range of cross-sections
More	www.knight-group.co.uk
	www.leemingpeel-springs.co.uk
	www.smihg.org; www.wirenet.org
Typical Applications	Music wire, oil-tempered wire, watch springs, vehicle leaf springs, clothes pegs, kitchen whisks

Stainless sprung steel fruitbowl
Designer: Takeshi Ishiguro
Concept project
Date: 1993

Metals provide us with the greatest potential for materials and objects to become animated. For hundreds of years we have understood that metals have the ability to store energy. Think of a spring or coil inside a clock where energy is stored in the metal springs and released, or perhaps modern examples like shape memory alloys ⬎. They all have the potential to move and change shape.

This steel ⬎ fruitbowl by Takeshi Ishiguro exploits the inherent tension that metal offers. He has created a piece of tableware ⬎ that is transformed by the objects it contains. The design understands and is sensitive to the fundamental principles of the steel wire ⬎ from which it is made.

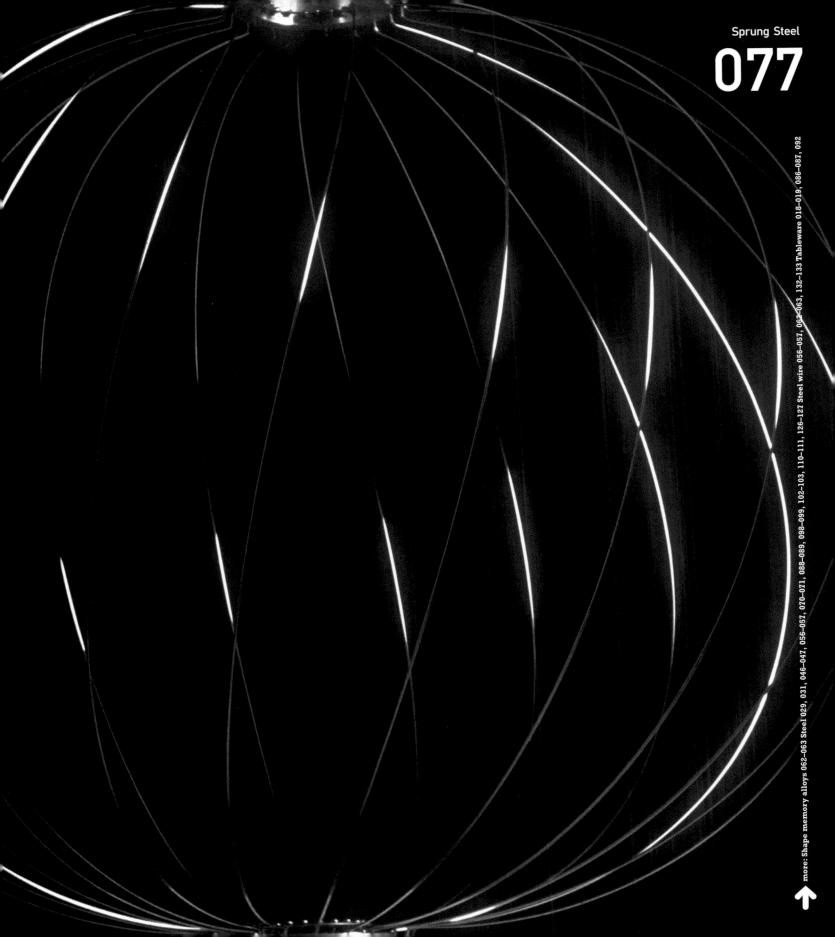

078

Less fuel, more glue

The luxury car company Lotus is developing the use of adhesives as an alternative to the traditional nuts and bolts, and welding methods used within vehicle construction. Using a single, part heat-cured epoxy adhesive reduces the number of nuts and bolts needed, resulting in an ultra lightweight ⬎ structure. The Lotus Elise model has a significantly smaller engine and gear box than standard cars, which means less fuel is consumed, and less power is needed to achieve higher performance. It is the first car to offer a true primary structure that is bonded with an adhesive.

Although this technology has been used within the aerospace industry for some time, the challenge at Lotus was to deal with the different stresses and potential crashing forces that cars are subjected to. Using a single-part, heat-cured epoxy adhesive reduces the number of nuts and bolts required. This factor, combined with the use of aluminum ⬎ extrusion, reduces weight considerably.

Dimensions	3785mm overall length; 1719mm overall width
Key Features	Allows for thinner wall sections
	Clean assembly
	No distortion
More	www.hydro.com
	www.vantico.com
	www.dow.com/automotive
	www.lotuseng.com
Typical Applications	Aircraft, shipping, and vehicle construction

Lotus Elise chassis with
epoxy-bonded aluminum
alloy extrusions
Designer: Julian Thompson
Structural Engineering: Richard
Rackham, Darell Greig, and
Kerry Osborne
First produced: 1996

New function

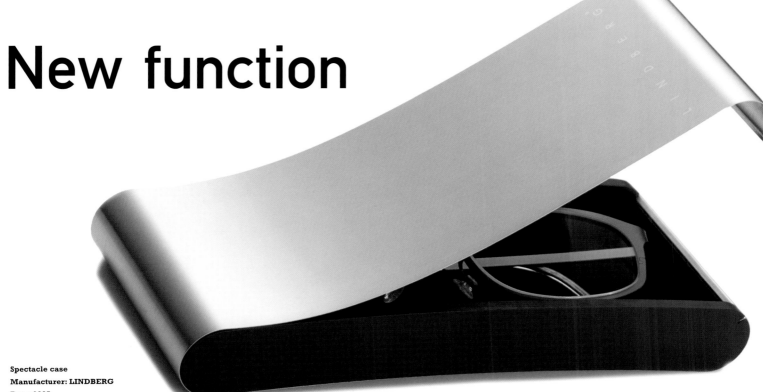

Spectacle case
Manufacturer: LINDBERG
Date: 1995

LINDBERG has designed a spectacle case to match its unique and simple spectacle ↘ frames. The case, like the frames, is inspired by the Danish/Scandinavian design traditions of simplicity, material minimalism, and functionality. The concept for this unique design is based on the fundamental idea of optimizing the choice of materials and design in relation to functional requirements.

The case is made from one thin sheet of brushed stainless steel ↘. It is an example of the optimum application of sheet steel and its inherent properties of strength and flexibility. The steel sheet has been shaped with the utmost accuracy to create the closing mechanism which functions perfectly without the use of hinges, screws, soldering or other external features, just like the frames. The case is functional as well as robust—ideal for contemporary, lightweight spectacles.

Dimensions	66mm x 153mm; 63mm x 143mm
Key Features	**Non-corrosive**
	Capable of an outstanding surface finish
	Excellent toughness
	Can be formed using a variety of processes
More	**www.lindberg.com**
Typical Applications	**Stainless steel has revolutionized industry. Generally used where there is the risk of corrosion and a need for heat-resistance, including kitchen equipment, tableware, architectural applications, engine components, fasteners, and tools and dies for production**

more: Spectacles 024 Stainless steel 018–019, 030, 036–037, 040–041, 046–047, 049, 050–052, 096–097, 106–107, 114–115, 123, 124–125, 132–133

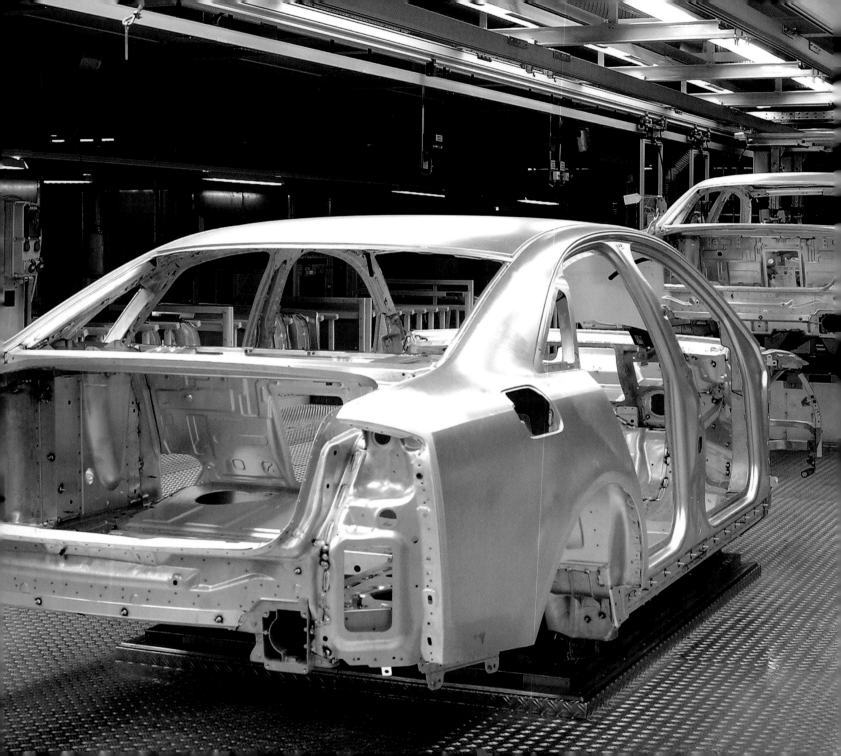

Lightweight

Dimensions	**2007mm x 1438mm x 5034mm**
Key features	**High strength-to-weight ratio**
	Forms alloys easily
	Excellent corrosion resistance
	Excellent heat and electricity conductor
	Ductile
	Recyclable
More	**www.audi.com**
	www.world-aluminum.org
Typical applications	**Vehicle construction, aircraft parts, kitchen utensils, packaging, furniture, strengthening large structures: the statue of Eros in Piccadilly Circus, London, and the top of the Chrysler building in New York**

**Audi A8
Design: Audi
Launched: 1994**

Aluminum ⊻ is a relatively recent addition to the world of metals. Audi have embraced this high-tech, lightweight material with its incredible mechanical properties, and made it a major feature of their brand—testament to their commitment to developing and using advanced engineering and materials.

Audi's development of lightweight ⊻ vehicles goes back to the beginning of the 20th century when they produced the NSU 8/24 car with its aluminum body. More recently the A2 and A8 models have exploited the material to an even greater degree—the A2 was the first volume-built vehicle with an all-aluminum body. This versatile metal has become so integral to Audi's business that in 1994 they inaugurated the Audi Aluminum Center in Neckarsulm, Germany, where aluminum and associated technologies are promoted and developed.

The A8 model offers a substantial weight reduction compared with similar cars. The space frame weighs only 215kg, almost half the weight of an equivalent frame in steel. To date, Audi have produced over 250,000 aluminum cars.

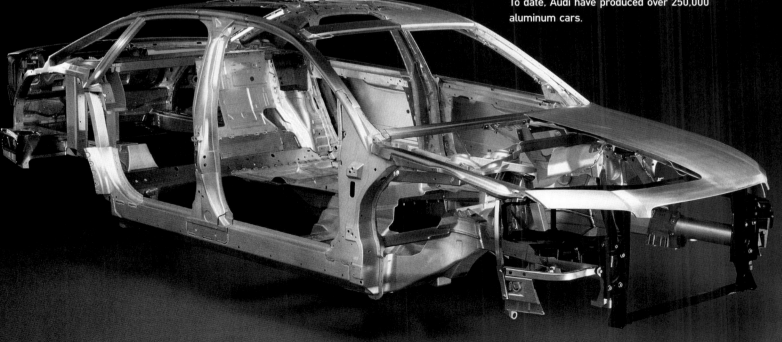

082

Soft metal

Dimensions	**690mm wide x 550mm deep**
Key Features	**Complex forms can be created in a single component**
	A range of thicknesses can be used
	Subtle details and forms can be created
	No spring-back issues
	A range of aluminum alloys can be used
Further Information	**www.ronarad.com**
	www.superform-aluminium.com
Typical Applications	**Superform components can be formed into many alloys for use in a range of industries including aerospace, transport, and furniture**

Ron Arad ⬎ has developed a collection of designs based on the challenge he sets himself of finding novel product typologies based on new manufacturing techniques. His body of work is filled with examples of furniture and products that are the result of applying new methods, often borrowed from other industries.

"I wanted to use the Superform process for furniture and had to wait a while until a suitable project came up; the first was a chair. Another opportunity arose when I was commissioned to do a sculpture in Milan, and eventually I was able to transfer the shapes we had made into plastic."

The Tom-Vac chair started life as a product made using the Superform aluminum process. This process exploits thin aluminum ⬎ alloys up to a maximum thickness of 10mm and offers the potential to create strong, lightweight shapes that would normally only be realized in plastic.

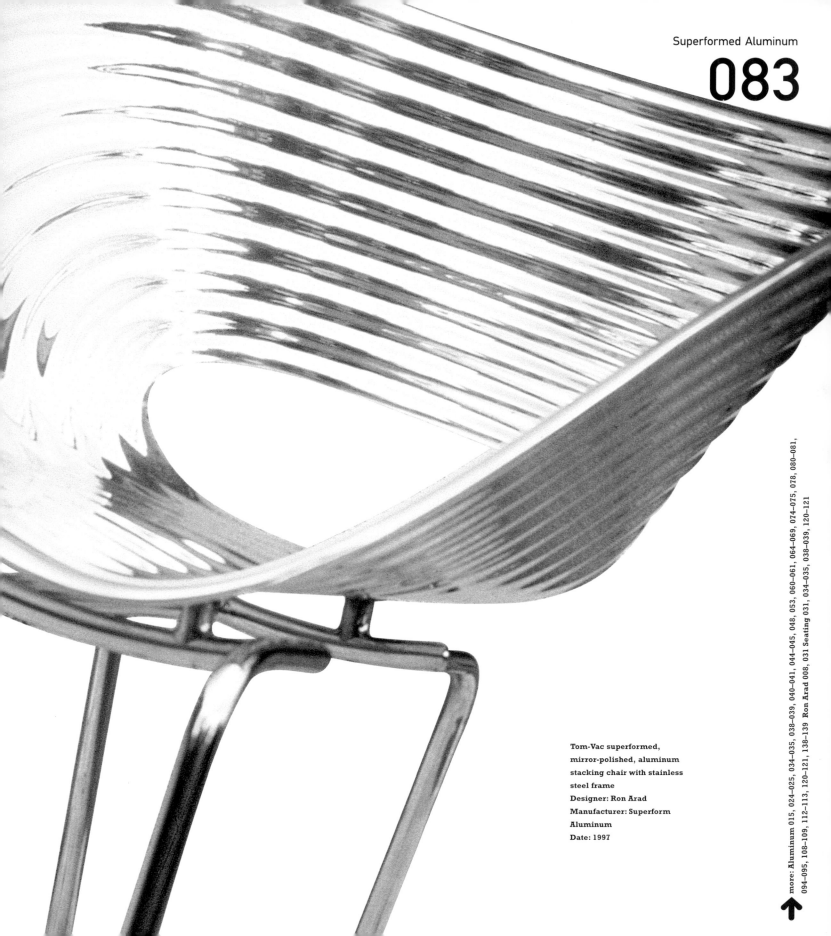

Tom-Vac superformed,
mirror-polished, aluminum
stacking chair with stainless
steel frame
Designer: Ron Arad
Manufacturer: Superform
Aluminum
Date: 1997

084

Tongue doodles

Ordering this jewelry by mail gives everyone a chance to become a designer. This unique jewelry design and production method honors the three-dimensional tongue doodle imprinted on individual sticks of chewing gum. Each simple stick of gum is a potential piece of jewelry just waiting to be brought to life by its chewer.

How to make your own brooch:

- Call up Ted Noten and ask him to send you one of his "Chew your own Brooch" chewing gum boxes
- Remove the chewing gum from the box and find a comfortable place, i.e. the bathtub, a nature spot, a subway etc. Then start chewing
- Take your time. Look on the back of the package for inspiration if needed. Create some different shapes ⬎. Once you have settled on your favorite design, send it back to Ted in the original box (mailing is included in the cost)
- Ted will then make a mould of your chewed gum and cast it in silver ⬎. After soldering a pin onto the back and plating it in 24 carat gold, he'll send you your finished piece.

Chew your own Brooch jewelry
Producer: Ted Noten
Date: 1998

Dimensions	**70mm x 24mm**
Key Features	**Unique approach to designer-maker relationship**
	Any shape is possible
	Can be applied to a range of metals
More	**www.tednoten.com**
Typical Applications	**Casting is used for forming virtually any shape. Applications other than jewelry include decorative figurines, statues, tableware, furniture, accessories, and industrial components**

Metallic skin

Key Features	**Decorative**
	Acts as a light barrier
	Printable and reflective
	Heat insulator and electrical conductor
More	**www.isseymiyake.com**
	www.metalfoils.com
	www.schlenk.de
	www.seppleaf.com
	www.gilders-warehouse.co.uk
Typical Applications	**Metal leaves are used in a range of applications including sweet wrappers, packaging for medicine and food, stamping foils, cable wrap insulation, and heat reflection**

Issey Miyake stands out as one of the most pioneering fashion designers of recent times. He has provided us with an ongoing spectacular feast of new fabrics ↘ and garments, often with incredible properties. He continues to break ground—his Starburst Collection is a range of clothes that are encased in metal. Paper-thin foils ↘ are heat-pressed onto the clothes, producing flat, foil-wrapped garments. When the garment is stretched over the body, the foil is torn open, creating a shredded-foil effect.

**Glove from the
Starburst Collection
Designer: Issey Miyake
Date: Autumn/Winter
Collection 1998**

more: Foil 130–131 Textiles 106–107, 108–109, 116–117

Shredded metal

Dimensions	**250mm x 380mm x 310mm**
Key Features	**Flexible production**
	No post-production finishing
	Intricate shapes can be cut
	Suitable for a range of materials
More	**ane.c@ofir.dk**
	www.vesselgallery.com
Typical Applications	**Intricate and fine patterns can be laser cut into many flat materials within many different engineering and domestic applications**

Laser cutting ↘ provides a clean, cost-effective way to transform flat sheets of materials and to create intricate patterns ↘. This shredded bowl challenges our perception of metals as being cold, rigid, and hard. It is made from a simple flat sheet that is transformed into a slumping organic form, completely altering the material's structural integrity.

"The starting point for all my work is a single sheet of metal. I enjoy this restricting process of developing a three-dimensional object from a two-dimensional sheet. I try to create a sense of movement, cutting into and shaping the sheet creates the illusion of light, spontaneous movement captured permanently in the metal. I'm often influenced by Japanese paper packaging and Scandinavian architecture, but my most important inspiration is the building site. To me, half-finished or half-demolished structures hold unexpected sculptural qualities and dramatic contrasts in the materials of brutality and beauty," says Ane Christiansen.

Shredded Bowl
Designer: Ane Christiansen
Self-initiated project
First produced: 1999

more: Laser cutting 046–047, 052, 102–103 Patterns 052, 116–117 Tableware 018–019, 076–077, 092

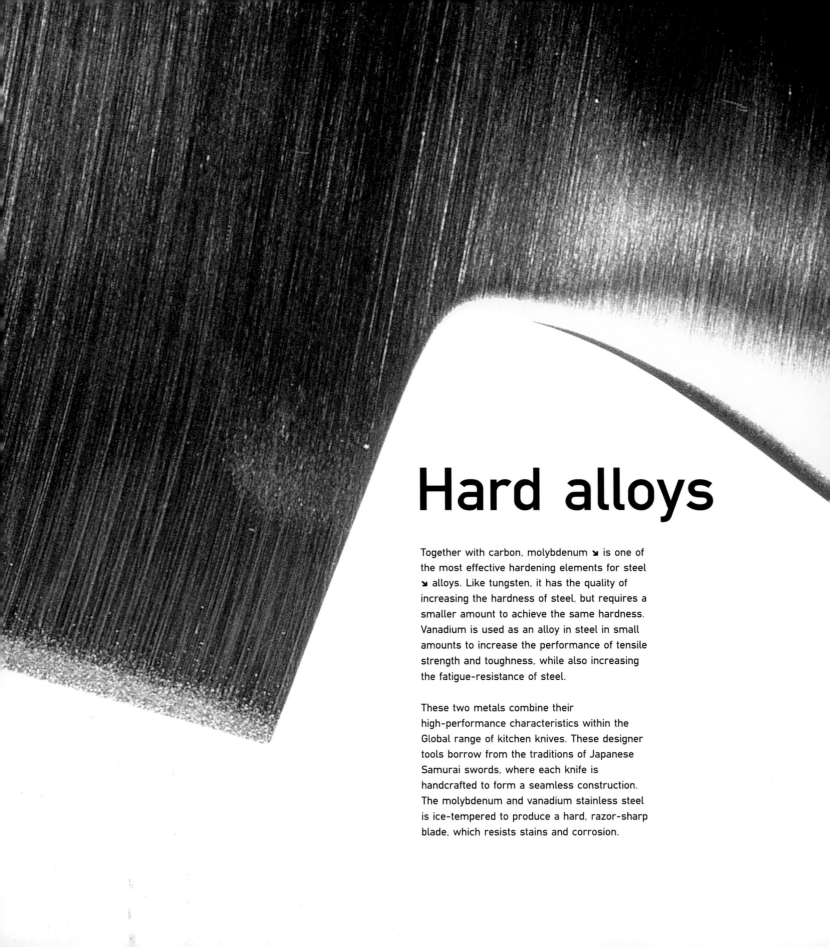

Hard alloys

Together with carbon, molybdenum ⬎ is one of the most effective hardening elements for steel ⬎ alloys. Like tungsten, it has the quality of increasing the hardness of steel, but requires a smaller amount to achieve the same hardness. Vanadium is used as an alloy in steel in small amounts to increase the performance of tensile strength and toughness, while also increasing the fatigue-resistance of steel.

These two metals combine their high-performance characteristics within the Global range of kitchen knives. These designer tools borrow from the traditions of Japanese Samurai swords, where each knife is handcrafted to form a seamless construction. The molybdenum and vanadium stainless steel is ice-tempered to produce a hard, razor-sharp blade, which resists stains and corrosion.

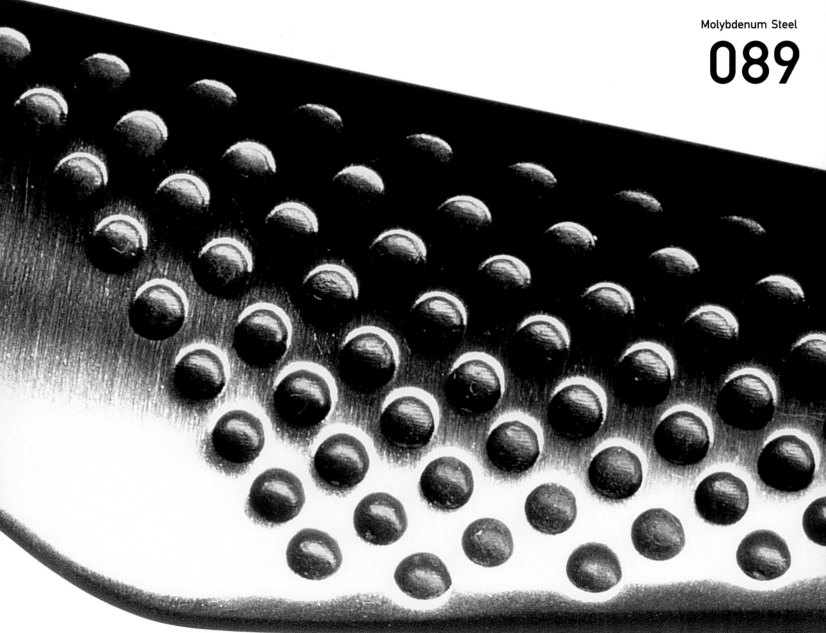

Dimensions	**2560mm long**
Key Features	**High tensile strength**
	Excellent hardness
	Good corrosion-resistance
More	**www.yoshikin.co.jp**
Typical Applications	**Molybdenum steel is used to replace tungsten in high-speed steels. It is also used as an alloy to increase deformation at high temperatures. Vanadium steel is used for forgings and cast steels for aircraft**

**Kitchen knife from the
Global range
Designer: Komin Yamada
Date: 1985**

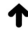

Musical instruments ⬂ are not designed, but are the result of trial and error, and always evolving; they are the balance of a perfect form with the right material. Like the other simple examples featured in this book, I enjoy the objects often discarded and unnoticed by designers due to their familiarity. With the exception of rock music, the combination of music and metal is not often noted. These brass ⬂ whistles follow the tradition of the brass instrument in an orchestra, where the metal and form work together to create a perfectly functional fine-tuned object.

The ACME Thunderer whistle is made from cartridge brass, a common 70 percent copper ⬂ and 30 percent zinc ⬂ alloy which is also referred to as "spinning brass", "extra quality brass", or "spring brass". Cartridge brass was found to be the best metal to use as it vibrates at just the right frequency. The whistle starts life as a flat sheet, and is cold worked to form three basic parts; together they require 32 operations to make a whistle. As with many metal objects, the whistle is plated with nickel ⬂ for a shiny finish.

ACME Thunderer whistle
Manufacturer: Acme Whistles

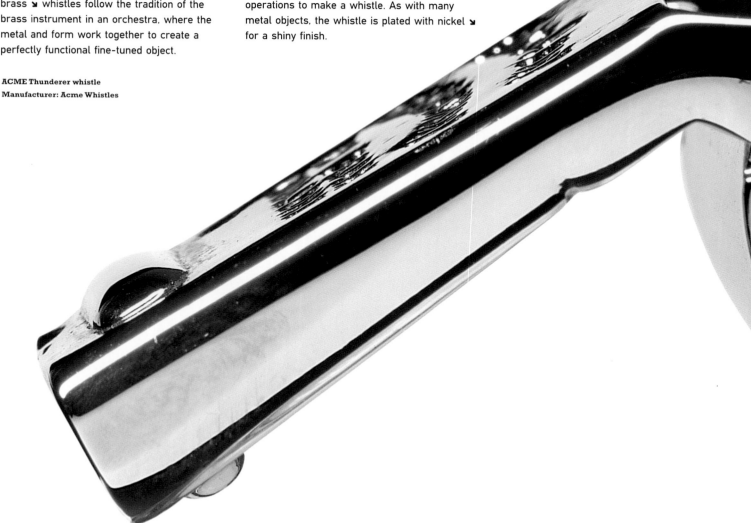

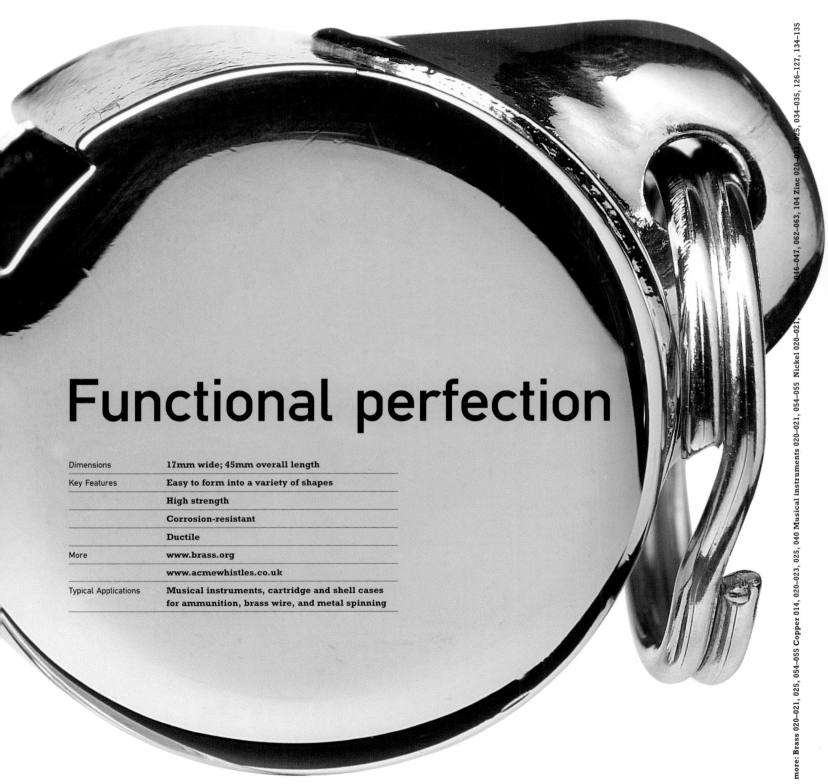

Functional perfection

Dimensions	17mm wide; 45mm overall length
Key Features	Easy to form into a variety of shapes
	High strength
	Corrosion-resistant
	Ductile
More	www.brass.org
	www.acmewhistles.co.uk
Typical Applications	Musical instruments, cartridge and shell cases for ammunition, brass wire, and metal spinning

The brief for this caraffe was to design a new range of tableware for an Italian tableware company. Afroditi Krassa was given the choice of a range of materials—she decided to use silver ⬎ partly because she had never used it before, and also because of the added value that this precious metal ⬎ offers.

"I decided that if you are going to pay a lot of money for a product you would probably want to keep it for a long time. So basically the best way to approach the design was to give it a form, which would reflect this longevity. I decided to strip the caraffe down to its simplest form by asking myself what is the simplest shape you could have? The outcome is a cylinder, which has been cut at an angle to give an ellipse, and a point which acts as a natural spout."

Caraffe
Designer: Afroditi Krassa
Manufacturer: Paola C
Date: 2001

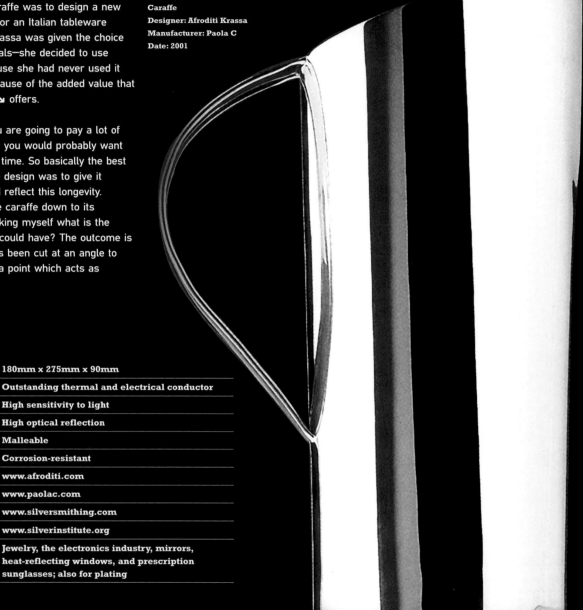

Dimensions	180mm x 275mm x 90mm
Key Features	Outstanding thermal and electrical conductor
	High sensitivity to light
	High optical reflection
	Malleable
	Corrosion-resistant
More	www.afroditi.com
	www.paolac.com
	www.silversmithing.com
	www.silverinstitute.org
Typical Applications	Jewelry, the electronics industry, mirrors, heat-reflecting windows, and prescription sunglasses; also for plating

Form follows material

Strength and beauty

This sheet steel ⬎ product from Corus has a ductility and lightness which also makes it suitable for book covers. This kind of product combines aesthetic and physical properties that offer a hardworking, scratch-proof surface.

Space is a steel advisory service for packaging designers and material technologists, set up by Corus Packaging Plus ⬎. They have helped designers realize packaging solutions for a range of projects, one of which was the steel cover for "Spoon" an innovative book showcasing the best in contemporary product design. This cover utilizes Promica® Pristine, a new polymer-coated steel product. The plastic coating allows for embossing and die cutting, and is resistant to staining.

"The main challenge was finding a metal that was strong enough to hold the spoon shape under the weight of 444 pages. This is where Space opened my eyes to the capabilities of steel and helped me find the perfect solution to the technical difficulties of my design," says designer Mark Diaper.

"Spoon"
Designer: Mark Diaper
Publisher: Phaidon
Published: 2002

Dimensions	300mm x 210mm x 40mm
Key Features	**Scratch-resistant**
	Fingerprint-resistant
	Lightweight
	Good surface finish
	Suitable for embossing and die cutting
More	**www.corusspace.com**
	www.corusgroup.com
Typical Applications	**Refrigerator exteriors, breadbins, toasters, and other domestic appliances, kitchenware, promotional packaging, and furniture**

more: Corus 042–043, 070–071, 124–125 Sheet metals 064–065, 066–067, 094–095, 122, 124–125 ↑

094

Simple production

"My aim was to produce a screen that creates a focal point wherever it is located in a room and which reflects the distinctive style of SUCK-UK by playing on the pin-up girl image," says Ken Hirose.

SUCK-UK have a diverse product range. Their designs are hard-edged, and usually dominate their surroundings, as well as being fun and glamorous. This contemporary screen with a light triggers feelings of curiosity and excitement through its sleek simplicity, and masculine, urban, punky, sexy, and sensational connotations. The pin-up image on the screen is created using CNC-punched holes of four different diameters, which is one of the most cost-effective sheet metal ⟶ manufacturing processes.

Pin-up Screen
Designer: Ken Hirose
Client: SUCK-UK
Date: 2003

Dimensions	80mm x 500mm x 1500mm in closed position
Key Features	Excellent corrosion-resistance
	High strength-to-weight ratio
	Easily forms alloys
	Excellent heat and electricity conductor
	Ductile
	Recyclable
	Non-magnetic
More	www.suck-uk.com
Typical Applications	Vehicle construction, aircraft parts, kitchen utensils, packaging, and furniture. Aluminum is also used for strengthening large structures including the Statue of Eros in Piccadilly Circus, London, and the top of the Chrysler building in New York

more: Sheet metals 064–065, 066–067, 093, 122, 124–125

096

Modern ritual

This simple Switchless Lamp fully exploits the magnetic, reflective, and conductive properties of stainless steel ⅄.

"My brief was to create an object with a single sheet of steel as its major structural element. I decided to exploit the intrinsic and not just the structural qualities of steel. Sheet steel thus became the main functional element, as well as the main structural element of the object. The sheet of steel acts as the reflector of the lamp ⅄, as a magnetic electrical connection, and as an electrical conductor. It is also the major structural element, holding the bulb and all other components in the correct position.

"This exploration led to a transformation of the process by which a lamp is traditionally made to function. A new sense of enjoyment and ritual is given to this basic daily activity. I was trying to evoke the way we experience lighting the candle today. The direct participation involved in lighting it gives it a sense of ritual and enjoyment," says designer Alvaro Catalan de Ocon.

Dimensions	125mm x 110mm
Key Features	Excellent toughness
	Hygienic
	Non-corrosive
	Capable of an outstanding surface finish
	Can be formed using a variety of processes
	Difficult to cold work
More	www.key-to-steel.com
Typical Applications	Austenitic stainless steel is used in housewares, industrial piping, and architecture. Martensitic stainless steel is used to make knives and turbine blades. Ferritic stainless steel is corrosion-resistant and is used for internal components in washing machines and boilers. Duplex stainless steel is highly resistant to corrosion and is used in aggressive environments

Switchless Lamp
Concept project
Designer: Alvaro
Catalan de Ocon
Date: 2003

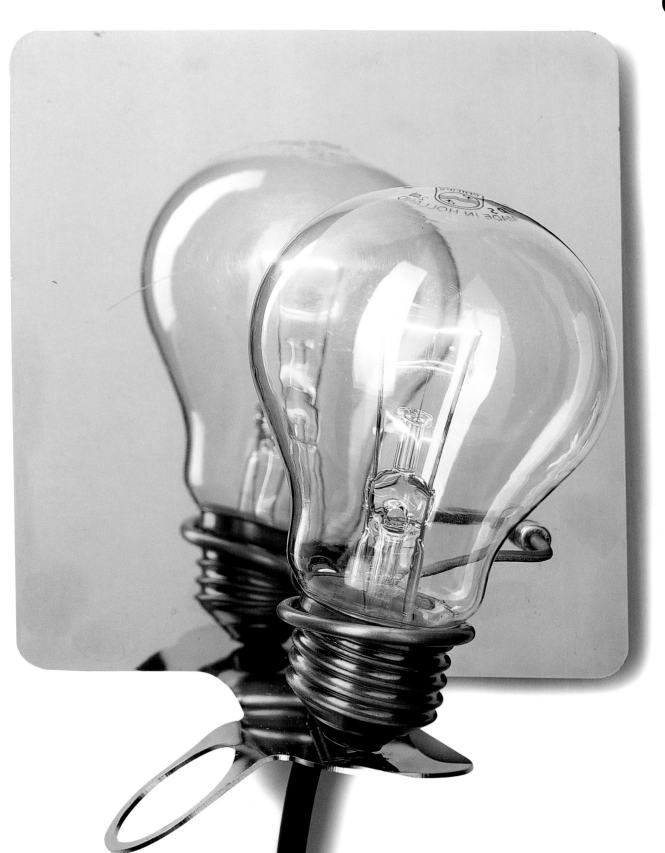

New perspective

All materials can be reinterpreted and their characteristics applied to new contexts. These discoveries occur not only through creative thinking but also by chance. The by-products of one material or the useless offcuts from a production process often can be used to fulfil a need for new product. Steel ↘ may not be the easiest material to work with or form without heavy industrial methods of production, but it is one of the cheapest materials available. Hence, we see steel cheaply mass-produced as wire wool, excellent for abrasive cleaning.

Steel wire wool cleaners

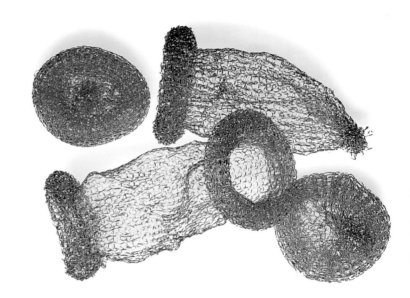

Key Features	Tough
	Easy to form
	Strong
	Relatively inexpensive
	Needs little energy to recycle
More	www.steel.org
	www.uksteel.org.uk
Typical Applications	Depending on the hardness of the steel and the amount of carbon it contains, carbon steels can fulfil an infinite range of uses. High carbon steels are used to make cutting tools and knives. Medium carbon steels are used for general construction and engineering. Low carbon steels are used for domestic products, furniture, car body panels, and packaging

more: Steel 029, 031, 046–047, 056–057, 070–071, 076–077, 088–089, 102–103, 110–111, 126–127

101 Industrial

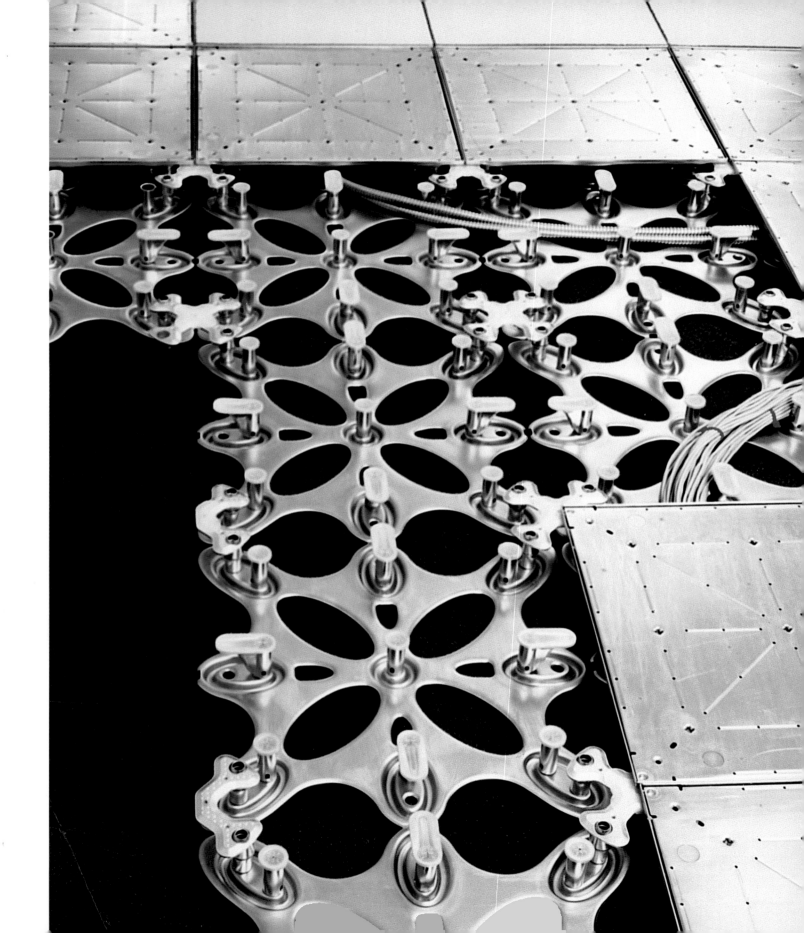

Intelligent flooring

"Steel ⬎ is my favorite material, it's a softer metal than people think, but it can change its properties more than any other metal. In car bodies, it's the material of choice, but I am sure you could now build a steel airplane with foil and cutting techniques like laser cutting ⬎.

"In the Emma flooring system, the reflective quality of peering into the floor was an image in my mind from the outset. It needed to show its intelligence; the galvanized finish ⬎ amplifies the pressed ⬎ details, "the organs," creating a patina and making it resistant to cleaning. I wanted the floor to be interesting even when in pieces because it is accessed regularly. The top tiles do not require tools or carpet glue yet will hold 454kg per 25mm². As offices are in a state of constant change, this floor is an alternative to panel systems. There is also a clear plastic tile that's very popular, intended to show data/power junctions so they do not have to keep maps," says designer Stephen Peart.

Emma flooring system
Designer: Stephen Peart
Client: Herman Miller, Inc.
Date: 1998

Dimensions	**500mm x 500mm x 80mm tiles**
Key Features	**Easily installed and relocated with no tools or skilled installation**
	No reconfiguration of electrical and data cabling
	Gives older brick and concrete buildings high-density power and data capability
	Can be used for interiors and exteriors
More	**www.ventdesign.com**
Typical Applications	**The Emma flooring system can be used with freestanding, relocatable furniture, offering an alternative to the bullpen panel systems**

more: Galvanizing 056–057, 126–127 Laser cutting 046–047, 052, 086–087 Pressing 038–039, 054–055 Steel 029, 031, 046–047, 056–057, 070–071, 076–077, 088–089, 098–099, 110–111, 126–127

104

Blastproof

Portcullis House in Westminster, London is a building designed to last. It accommodates Members of Parliament so was designed to withstand terrorist attacks. The use of aluminum bronze, a material traditionally used in extremely tough environments, goes some way to fulfilling this demanding criteria.

Aluminum bronzes are distinguished by their high strength and corrosion-resistance, which, in many ways, is better than stainless steel. It is a bronze alloy, which contains up to 14 percent aluminum, and smaller amounts of nickel ↘, iron ↘, manganese, and silicon. The variations of the combined proportions of these elements results in a range of alloys with excellent toughness and strength.

Aluminum bronze is used as part of the roof structure and on the façade of Portcullis House, where the main requirements were for strength, durability, and ductility. In its clean, raw state, aluminum bronze is very bright; for Portcullis House, it was oxidized to age the surface.

Unlike stainless steel, aluminum bronze is readily machinable. Also it has a relatively low density, which allows for designs with thinner sections to be produced.

Portcullis House, London
Architect: Michael Hopkins
& Partners
Client: Parliamentary
Works Directorate
Date: 2000

Key Features	Outstanding corrosion-resistance
	High strength
	High wear-resistance
	Ease of casting
	Low magnetic permeability
More	www.hopkins.co.uk
	www.cda.org.uk
	www.watsonsteel.co.uk
	www.portcullis-house.com
Typical Applications	Ship propellers, casting molds, decorative ware, heat-exchanger tubing, wheel nuts on cars, gear wheels for braking systems, mine-hunting vessels where low magnetic permeability is required, and expansion joints for masonry fixings

more: Iron 016–017, 022–023, 029, 031 Nickel 020–021, 030, 041, 046–047, 062–063, 090–091

Surface code

In 1999, furniture designer Tom Longhurst and graphic designer Simon Procter combined their disciplines to create their debut product. The market had not yet seen a high-end sculptural tile in metal. They experimented with various metals to create different textures and forms, using Morse Code as their theme. They eventually settled on aluminum as it met most of their requirements for production.

The manufacturing process of sand-casting ⟶ meant that they could meet both small and large production runs, and no structural fixings were needed because of its lightness. Most importantly the finished tiles had a hand sculpted aesthetic. The "Morse" tiles were originally designed for prestige architectural commissions but their exposure has extended well beyond this niche market to more mainstream environments such as kitchens and nightclubs.

"Morse" aluminum tiles
Designers: Tom Longhurst,
Simon Procter
Date: 1999

Dimensions	315mm x 315mm x 6mm; 9 tiles make 1m^2
Key Features	**Durable in both interior and exterior environments**
	Handmade appearance
	Lightweight
	Endless possibilities for design layouts
	Messages can be written in code
	Gluing possible (no fixings)
	Can be sold as a single art piece or as signage
More	**www.idaho1.co.uk**
Typical Applications	**High-end hotel receptions, bars, nightclubs, and restaurants, airline lounges, and large show rooms. These tiles have also been used as a background for photo shoots including for a Levi's clothing range**

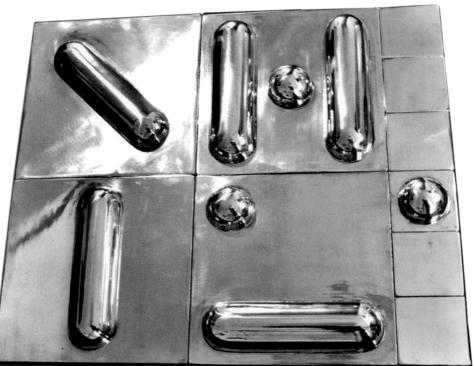

more: Casting 025, 034–037, 044–045, 084

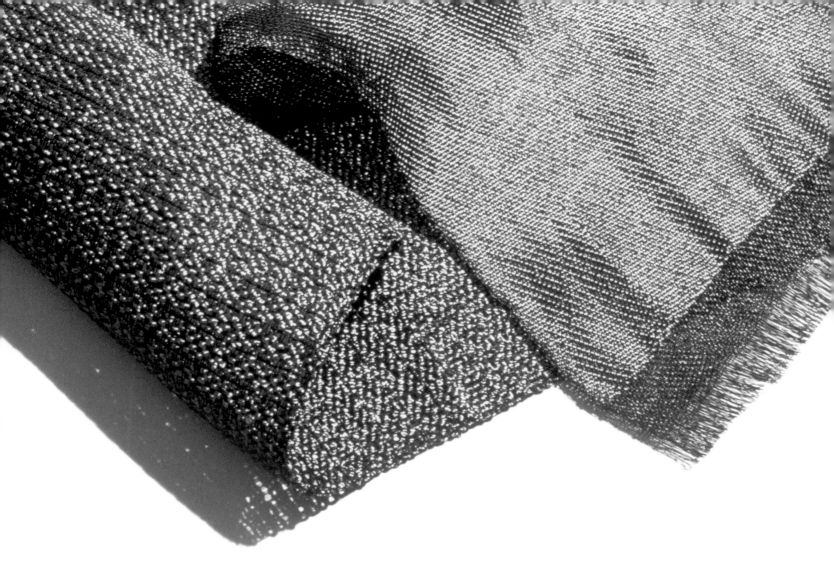

Flexible sheet

Dimensions	Development piece approx 600mm x 1200mm
Key Features	Flame-resistant
	Unique visual quality
More	www.knolltextiles.com
Typical Applications	Endless possibilities for interior and exterior coverings

In 1998, Suzanne Tick was asked to design the banners for an exhibition on Japanese textile design at the Museum of Modern Art in New York. Always looking for new materials to work with, her eye fell upon an industrial stainless steel ⬐ yarn from Japan used to line tires. Suzanne was then asked to weave an entry for the exhibition as well. This prototype proved inspirational for a collection of wall coverings and upholstery fabrics she designed for Knoll Textiles a few years later.

"This product can be woven by hand, though in development, the fiber would shed, and soon our fingers were tingling. When we went from hand weaving to production weaving, the stainless steel fiber was too strong yet not rigid enough for the loom to cut in the weaving process, therefore we never went to market with this. The original intention for this product was to be a 100 percent stainless steel drape, which would be flame-resistant and glimmer with the light," says Suzanne Tick.

100 percent woven stainless steel prototype
Produced by: Suzanne Tick for Knoll Textiles
First produced: 1999

more: Stainless steel 018–019, 030, 036–037, 040–041, 046–047, 050–052, 079, 096–097, 114–115, 123, 124–125, 132–133 Textiles 085, 108–109, 116–117

Metallic tissue

Textile ⬎ technology is an astonishing area for the number of industries it extends into, encompassing virtually all areas of engineering and design, from the wearable to the habitable. It is not just the arenas in which they are used but the fact that textiles can incorporate natural and synthetic fibers made from glass, ceramics, and metals. These advanced materials can be molded and formed to create three-dimensional pieces. Even when their purpose is purely decorative, the industry is revolutionizing the way textiles are perceived.

Charisma is the brand name of a range of intriguing sheets of metal with a structure that consists of thousands of long, thin aluminum ⬎ fibers compressed together in a polyester matrix and produced in a vacuum to form a totally flat sheet. This metallic material, which is available in four finishes was originally designed for window blinds. The pattern comes from the swirl of fibers formed on the sheet which is highly crease-resistant and feels more like paper than fabric. This material is crying out for designers to find new areas in which to use it.

Dimensions	2100mm x 40m rolls
Key Features	Unique decorative potential
	Resin can be added to form a laminate
	Flat
More	www.jm-textile.com
Typical Applications	The main application for these textiles has so far has been in window blinds. They have also been used as part of moldings to produce decorative surfaces

Charisma metallic textiles
Launched: 2002

110

Decorative corrosion

One of the most interesting qualities of a piece of metal is its living surface. Like wood, metals are transformed by nature, creating patterns that remind us of the earth that they come from. Corrosion is a fascinating aspect of their behavior, which can transform shiny surfaces into unique, decorative patterns and textures. In a controlled environment, this corrosive process can be exploited to create beautiful ornamentation.

French architect Jean Nouvel designs buildings that are sympathetic to their surroundings. So it follows that a steel building which is surrounded by water should make some reference to the corrosion that takes place when these two natural elements come together.

Floating on Lake Morat in Switzerland, near the French border, this cube of 4,000 tonnes of rusty steel, was designed by Jean Nouvel for the Swiss Expo 2002. Resting on a platform of reinforced concrete, and rising some 30m above the water, the rusty ↘ box exploits the transitional effect nature has on steel ↘.

Dimensions	27,600m² floor area
Key Features	**Tough**
	Easy to form
	Strong
	Relatively inexpensive
	Needs little energy to recycle
More	**www.jeannouvel.fr**
Typical Applications	**Construction, shipping, production tooling, bridges, cars, railways, furniture, household goods, and architecture**

Monolith
Designer: Jean Nouvel and
GIMM Architekten
Client: Swiss Expo 2002

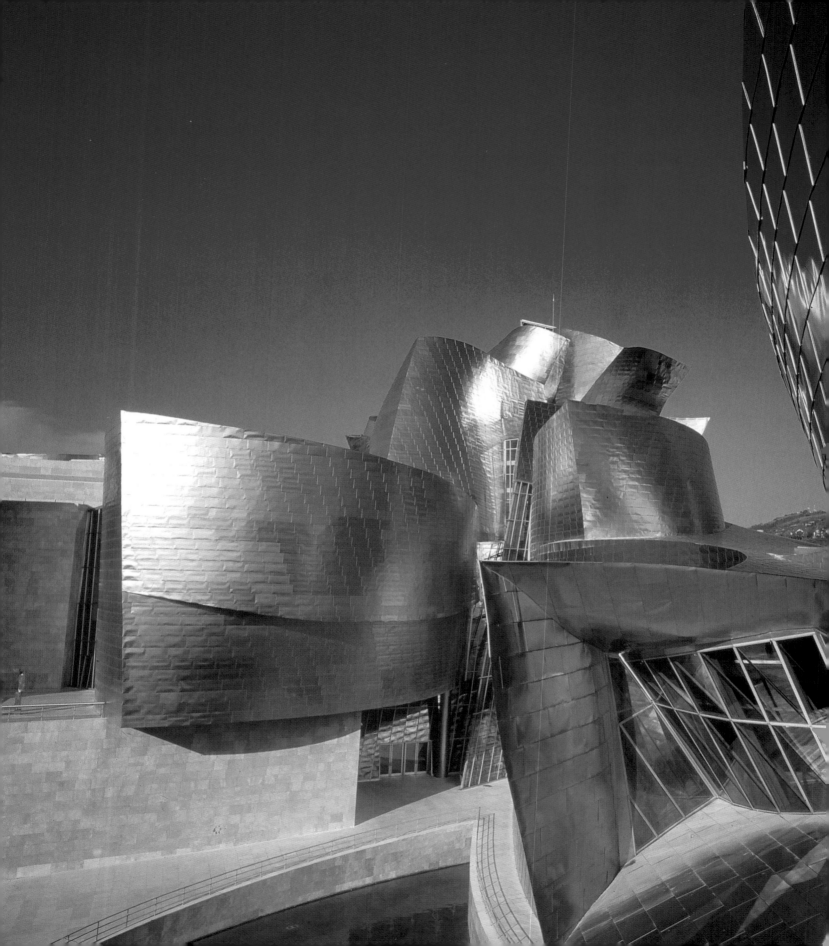

The individual paper-thin sheets of titanium ↘ on the surface of the Guggenheim Museum in Bilbao in Spain are its trademark. Each sheet is approximately 609.6mm by 914.4mm, about 0.38mm thick, joined together with a lock seam. When the wind blows, it gets underneath the surface of the sheets and flutters.

Approximately 40 percent the weight of steel, titanium has one of the highest strength-to-weight ↘ ratios of any metal. Commercial grades are about 99 percent pure but, its biggest commercial value and use is as an alloy. It is alloyed with aluminum ↘, columbium, vanadium, zirconium, tin, and molybdenum ↘. In more industrial applications, titanium alloys are used in aircraft fabrication and surgical implants. Corrosion-resistant applications include chemical and marine equipment.

Titanium oxide is also used as a white pigment in paper paints and plastic. Its exceptional ability to absorb UV light energy improves the weatherabiliy and durability of plastics.

Guggenheim Museum, Bilbao
Designer: Frank O. Gehry
Date: 1997

Titanium skins

Key Features	Extremely high strength-to-weight ratio
	Excellent corrosion-resistance
	Difficult to cold work
	Good weldability
	About 40 percent lighter than steel but 60 percent heavier than aluminum
	Low electrical conductor
	Low thermal expansion
	High melting point
More	www.titanium.com
	www.titanium.org
	www.guggenheim-bilbao.es
Typical Applications	Golf clubs, tennis rackets, laptops, cameras, casings, surgical implants, aircraft structures, chemical and marine equipment. Also as a white pigment for paper, paints, and plastic

more: Aluminum 015, 024–025, 034–035, 038–039, 040–041, 044–045, 048, 053, 060–061, 064–069, 074–075, 078, 080–083, 094–095, 108–109, 120–121, 138–139 High strength-to-weight 024 Molybdenum 041, 088–089 Titanium 024, 062–063, 134–135

Sun protection

Dimensions	**Each section 4mm high**
Key Features	**High sun protection**
	High visibility
	Energy efficient
	Can withstand winds of up to 55km/h
More	**www.clauss-markisen.de**
	www.ise.fhg.de
Typical Applications	**Sun protection**

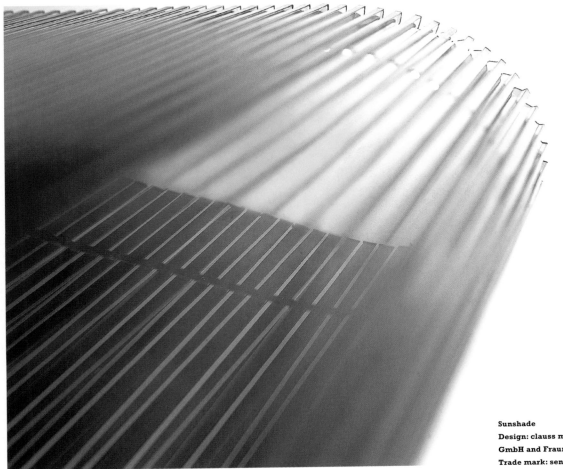

Sunshade
Design: clauss markisen Projekt
GmbH and Fraunhofer ISE
Trade mark: senn_®

The increasing use of large sheets of glass within architecture gives the obvious benefit of natural light, but also allows too much sun and heat into buildings. This award-winning transparent sunshade system is made of roll-formed, hollow sections of stainless steel ↘, and was developed by Clauss Markisen and Projekt GmbH, with Tilmann Kuhn, who focused on the shape of the steel section.

The roll-up sunshade transfers very little energy into buildings and can withstand winds up to 55 km/h. The height of one hollow section is 4mm, and the gaps between the sections amount to 20 percent of the total area of the blind, providing good visibility as well as sun protection. The optimized shape of the sections of stainless steel provide shade from direct sunlight, even when the sun is more than 20 degrees above the horizon, which reduces air-conditioning costs considerably.

"Maximizing energy efficiency and daylight should be standard when planning and designing buildings. The more daylight and solar energy are utilized in a building, the more important it is to balance the supply of daylight, glare protection and overheating protection; these three aspects are inseparable," according to Tilmann Kuhn.

more: Stainless steel 018–019, 030, 036–037, 040–041, 046–047, 050–052, 079, 096–097, 106–107, 123–125, 132–133

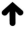

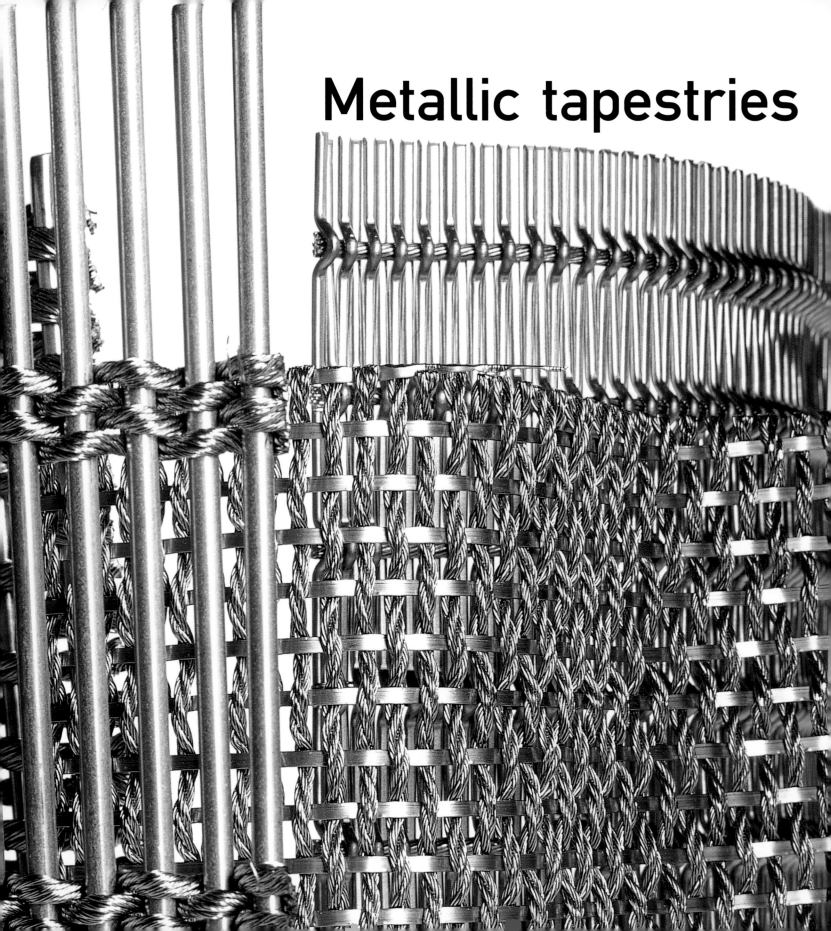

Metallic tapestries

These metallic, architectural fabrics ➘ can be used to create beautiful, sweeping drapes and tapestries. There are endless optical and functional possibilities within interior and exterior applications for these revolutionary materials. Metallic fabrics have translucent, delicate surfaces that can act as screens to hide pipes, sprinkler systems, acoustic insulation, and so on without hindering their function.

The metallic sheets are an interesting combination of stainless steel mesh, chains, and woven structures, providing a durable, non-flammable alternative to traditional textiles. On a large scale, the palette of patterns ➘ and textures can be exploited to dramatically change the surface of a building. As large, textured sheets, they are transformed into metal curtains, carpets, and seductive backdrops due to their ability to reflect so much light.

Architectural metal screens
Manufacturer: Gebr
Kufferath AG
Date: 1994

Dimensions	**8m maximum width; unlimited length**
Key Features	**Decorative**
	Wide range of woven styles
	Non-flammable
	Highly durable
	Easy to clean
	Graffiti deterrent
	Fireproof
	Corrosion-resistant
More	**www.gkd.de**
	www.creativeweave.com
Typical Applications	**To date, these products have been used mainly for architectural and interior purposes including building facades, wall partitions, exhibition stands, screens, ceilings, handrail barriers, wire weaving mills, and reflective surfaces**

more: Patterns 052, 086–087 Textiles 085, 106–109

119 Surface

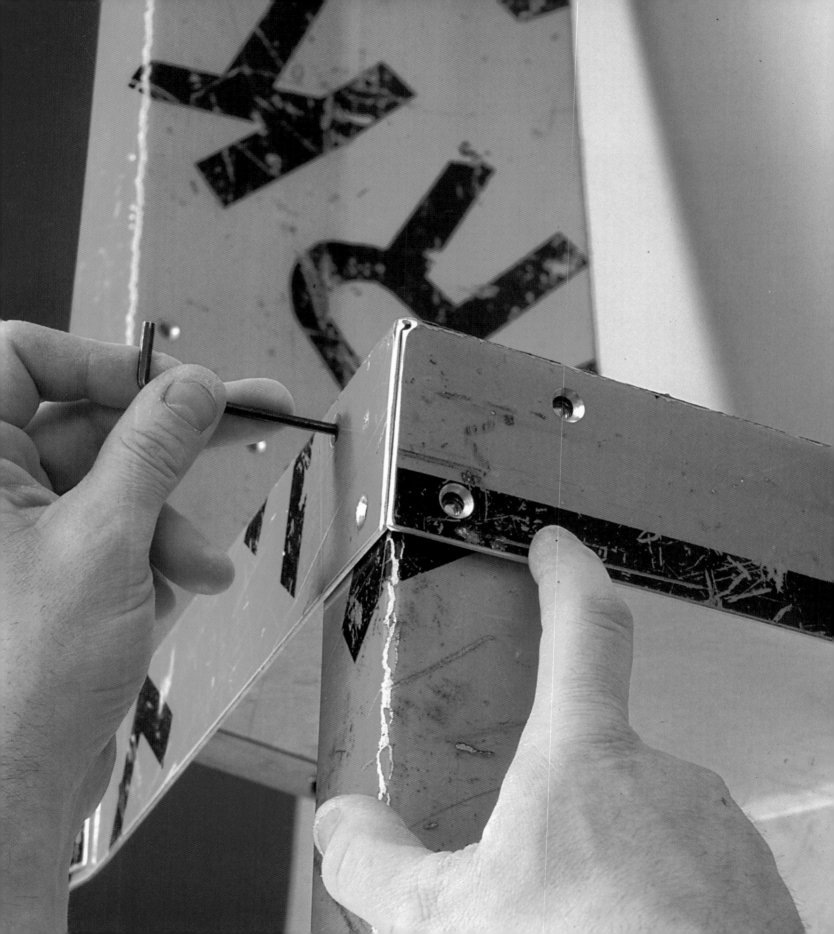

Humanufacturing

Once separated from any additives, many metals can be reused and recycled in countless forms. Designer Boris Bally not only embraces metals for their sustainable qualities, he also ensures that their former life is respected in the new forms that he creates. He calls the process of making these aluminum ↘ chairs "Humanufacturing", as they are handmade from collected scrap, and require only light equipment to form.

Ingredients
- 99 percent recycled metals
- Virgin metals
- Steel fasteners
- Aluminum tubes

Method
- Bally selects scrap signs for their imagery, condition, material, thickness, and surface
- Blanks are traced with a template and cut to size with a metal bandsaw
- The parts are shaped using a small brake press. Holes are drilled and edges de-burred. The tongue-and-groove pattern in the seats is shaped with a jigsaw and jeweler's files
- Screws are inserted and the parts aligned. The feet are cut from tube and turned on a small lathe. Champagne corks are slotted in and the tubes are fixed to the legs
- The chairs are taken apart and each component is scrubbed by hand
- Parts are inspected and stamped
- Final de-burring, then spray and seal
- Parts are re-assembled, inspected for fit, then taken apart and packed in a recyclable cardboard box ready for shipping

New Transit chairs
Designer: Boris Bally
Date: 2000

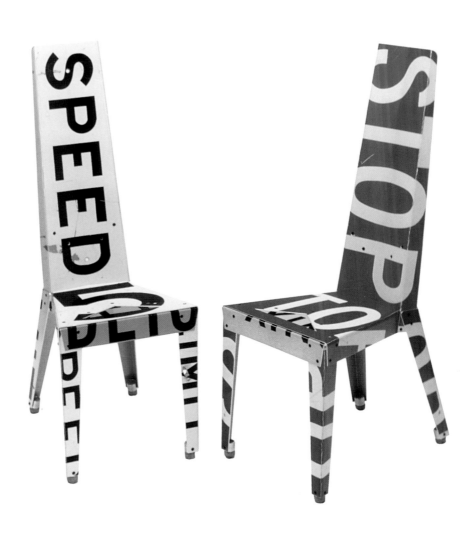

Dimensions	200mm high x 406mm wide x 533mm deep
Key Features	Recycled waste material
	Low-tech production
	Handmade
More	www.borisbally.com
	www.snagmetalsmith.org
Typical Applications	Aluminum is recycled in many forms, large amounts of which are melted and reformed

Durable

Dimensions	**225mm x 104mm x 129mm; 1mm thick**
Key Features	**Corrosion-resistant**
	Highly durable
	Infinite range of colors
	Can be used on a range of materials
More	**www.bludot.com**
	www.powdercoating.org
Typical Applications	**Powder coating is used in many diverse areas, from the automotive industry, where it is used for car body panels, to washing machines, refrigerators, bicycles, and filing cabinets**

Desktop CD holder
Designers: John Christakos,
Charles Lazor, Maurice Blanks
at Blu Dot
Client: Blu Dot
Date: 1998

Principally driven by the desire to protect, metal finishes offer a huge range of surface designs. These coatings provide opportunities to alter the visual and tactile qualities of the base materials. The glassy, hard, enamelled finish of powder coatings combines raw, industrial function with a brutally effective, protective layer. Powder coating uses an electrically-charged ↘ pigment together with resin powder. Similar to the build-up of static electricity on plastic combs, the powder is attracted to the metal, building up an even coating. Blu Dot use this hard coating to enhance many of their domestic accessories.

The pleasure of self-assembly with this Blu Dot range of products is derived from the ability of the metals to bend easily and hold their shape. Carefully measured slots reduce the amount of material on the fold lines, allowing the metal to bend with the correct degree of resistance, while holding its final shape. From flat sheet ↘ to three-dimensional product in minutes, this is flatpack in its simplest form.

more: Electrical currents 128–129, 134–135 Sheet metals 064–067, 093, 094–095, 124–125

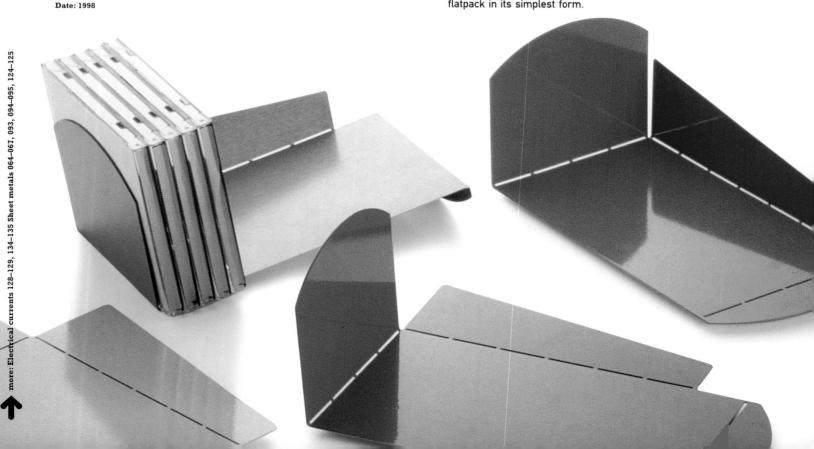

Highly-polished finish

The most common form of chromium ⊾ exists within a stainless steel ⊾ alloy, where it is used to increase hardness. It is a bright white metal with a bluish tint; its main characteristics being its hardness and its resistance to corrosion and tarnishing. Chrome plating is used within engineering and decorative chrome plating is often used as a top coat for bright nickel, giving a highly-polished, mirror-like finish. As a decorative finish, it is applied in a very thin coating as little as 0.006mm thick. These taps marry form and surface to produce a design that reflects the movement of water. The surface fits with the hygienic, hard, shiny coatings of glazed ceramics and enamelled surfaces found in most modern bathrooms.

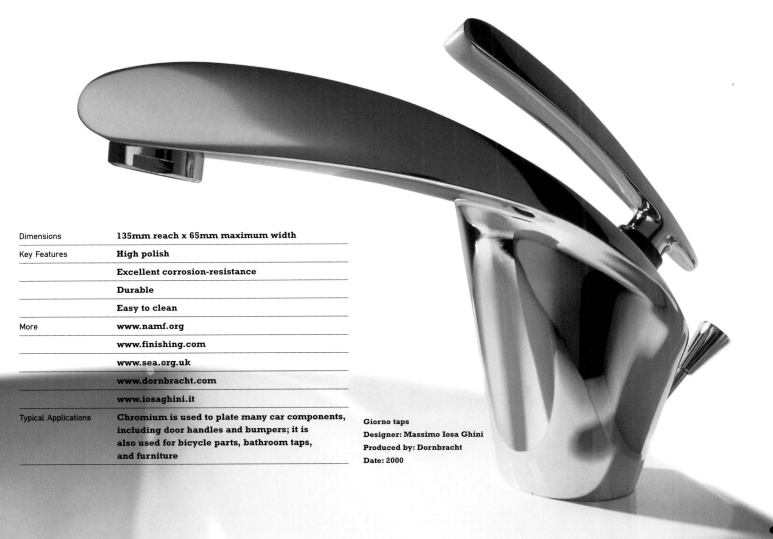

Dimensions	**135mm reach x 65mm maximum width**
Key Features	**High polish**
	Excellent corrosion-resistance
	Durable
	Easy to clean
More	**www.namf.org**
	www.finishing.com
	www.sea.org.uk
	www.dornbracht.com
	www.iosaghini.it
Typical Applications	**Chromium is used to plate many car components, including door handles and bumpers; it is also used for bicycle parts, bathroom taps, and furniture**

Giorno taps
Designer: Massimo Iosa Ghini
Produced by: Dornbracht
Date: 2000

more: Chromium 030, 041, 136–137 Stainless steel 018–019, 030, 036–037, 040–041, 046–047, 050–052, 079, 096–097, 106–107, 114–115, 124–125, 132–133

New experience

Pre-coated metals offer designers a range of readily available, decorative, functional surfaces. Corus offer a range of coatings including Colorcoat, a liquid-applied paints system; Stelvite, a polymer-film laminate bonded to the metal, and Colorstelve, a liquid-applied system topped with a polymer-film laminate.

This urinal project, sponsored by Corus ↘ demonstrates a new application for their pre-finished steels: "The project give urinals a face-lift. The urinal is made from pre-coated sheet ↘ stainless steel ↘ with an antibacterial coating over a variety of graphic images. Some of these images employ thermochromic pigment, which responds to the temperature of urine. In this way, some of the tedium or anxiety of using public urinals is alleviated: pissing can be fun!" says desiger George Walker.

"Heat" urinal
Designers: George Walker,
Daniel Liden, and Yasuyuki
Sakurai at the Doh Partnership
Concept project for Corus
Date: 2002

Dimensions	Up to 2000mm high
Key Features	Outperforms conventional post-coated metals
	Simplifies production (no post-coating)
	Cost-effective
More	dohpartnership@hotmail.com
	www.corusgroup.com
	www.metals4design.com
Typical Applications	Areas that require good wear resistance, including building components such as doors and profiled wall cladding; domestic appliances, including housings for washing machines, various parts for the automotive industry, bakeware, packaging, and furniture

more: Corus 042–043, 070–071, 093 Sheet metals 064–067, 093–095, 122, 124–125 Stainless steel 018–019, 030, 036–037, 040–041, 046–047, 050–052, 079, 096–097, 106–107, 114–115, 123, 132–133

Self-healing

Think of old steel wheelbarrows that sit in gardens without rusting, or of the dull finish on metal watering cans. This is the result of galvanizing—the process of applying a protective coating of zinc ⬎ to steel or iron. Everyone is familiar with galvanizing ⬎, if not by name then by its distinctive finish, associated with a guaranteed corrosion-resistant product. From plant pots and buckets to nuts and bolts, a galvanized finish is characterized by a mottled, multi-textured surface.

Galvanizing protects metals from corrosion. Metals corrode when exposed to the atmosphere in an attempt to revert back to their original state. Galvanizing is one of the most effective corrosion-resistant treatment for metals. It gives metals an extremely tough quality, and, depending on the environment and the thickness of the metal, it can last up to 150 years. Even when scratched, the coating corrodes, sacrificing itself to protect the steel ⬎ from being tarnished.

There are three main processes used to apply the protective coating: the metal to be galvanized can be sprayed, electroplated or dipped in a bath of molten zinc. The mottled, multi-textured, galvanized finish is characteristic of dipped steel.

Key Features	High corrosion-resistance
	Cost-effective
	Easily applied
	Maintenance-free
	Scratch-resistant
	Excellent abrasion-resistance
More	www.zinc.org
	www.iza.com
	www.hdg.org.uk
Typical Applications	Garden products, furniture, roofing, steel cables for construction, I-beams, nuts and bolts, steel decking, and metal mesh

Galvanized bucket with lid

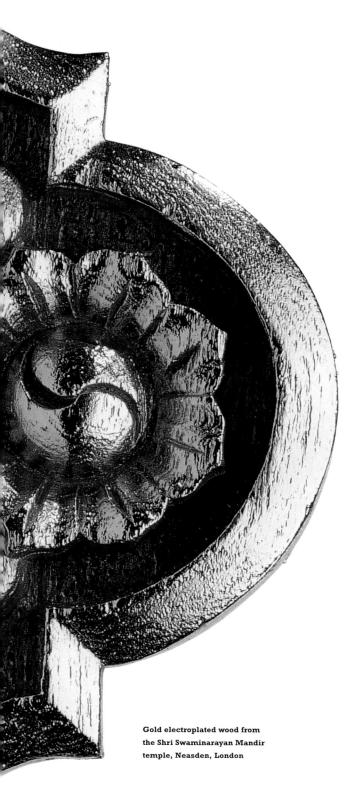

The surface of an object acts as a boundary between that object and the atmosphere. This barrier can be natural or it can be created to act as a decorative or a protective coating. Some metal alloys have an invisible, self-healing coating, and there a few that are used to form new coatings on different materials.

Electroplating ↘ is the process of applying a metal to the surface of another material to form a coating by means of electrolysis. It involves two main elements: a cathode and an anode in an electrolyte solution. The cathode is the object to be plated and the anode is the metalizing coating. A direct current moves metal ions from the anode to the cathode. Virtually anything can be electroplated. These fake surfaces offer materials new sensory qualities, challenging preconceptions and conventions, as with this gold ↘, electrically-conductive wood.

The surface

Dimensions	150mm^2
Key Features	Enhances surface decoration
	Improves corrosion-resistance
	Improves electrical conductivity
	Protects materials from electromagnetic and radio frequency radiation
More	www.namf.org
	www.finishing.com
	www.sea.org.uk
	www.bjsco.com
	www.aesf.org
Typical Applications	Electroplating is mainly used to coat metals. This can take the form of silver-plated cutlery, jewelry, electrical and engineering components, and tableware. Also used for decorative purposes

Gold electroplated wood from
the Shri Swaminarayan Mandir
temple, Neasden, London

more: Electroplating 054–055, 126–127 Gold 014–015, 018–019, 022–023, 028, 074–075

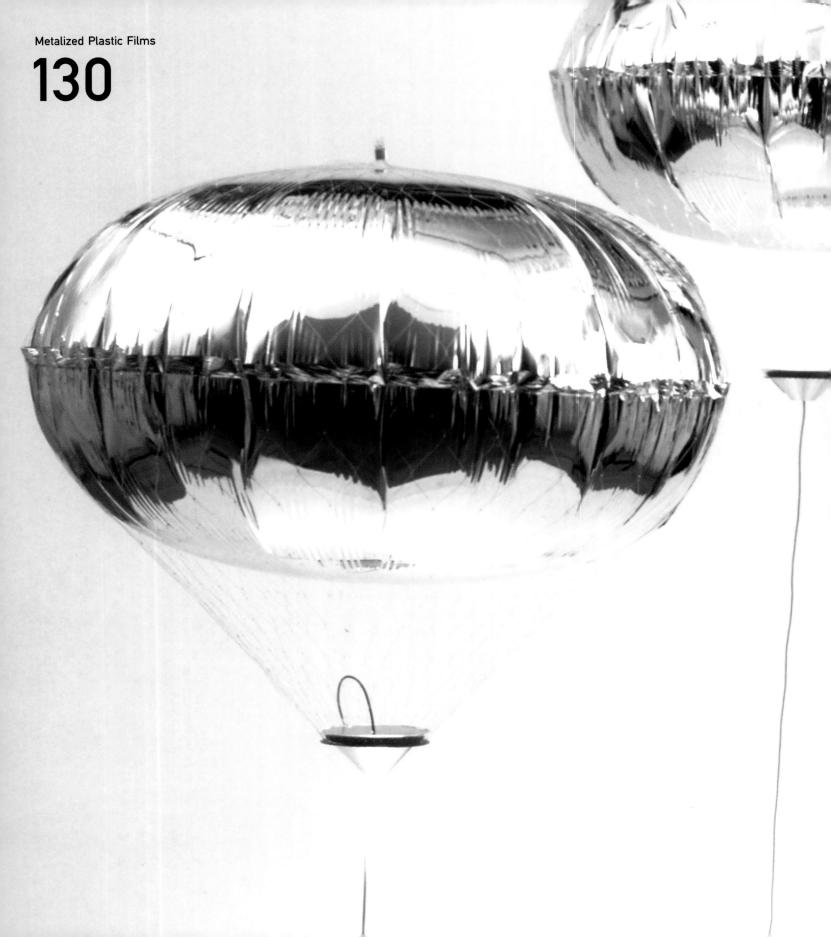

Designer Afroditi Krassa says of her innovative "Floating Light": "Metallic plastic was used for this project for functional reasons. Mylar® was the lightest material that will hold helium for a long time. There are other materials that are used for balloons, like latex or fabrics coated with polyurethane, but these are too heavy and would have required a much larger balloon diameter just to lift the material.

"One option was to have the light on the inside of the balloon but this brought other problems. Mylar® comes in a white finish for people to print over, but I decided to use the reflective nature of this metallic surface as a reflector for the light ↘.

"The nylon net holds the balloon and the light source, which is a cluster of 91 LED lights. The balloon acts as a reflector and the whole thing is anchored by this base which holds all the electronic gear and extra cable, which can be used to adjust the height of the light."

Light reflector

Dimensions	1000mm tall x 1000mm diameter
Key Features	Gas barrier
	Light barrier and reflector
	Allows for printing
	Good heat insulator
	Electrical conductor
More	www.afroditi.com
	www.dupontteijinfilms.com
Typical Applications	Metal is used as a coating on plastics to fulfil many functions from foils in food packaging to hot air balloons. Mylar® allows for a unique combination of plastics and metals in products such as magnetic audio and video tape, capacitor dielectrics, packaging, cable wrap insulation tape, and drumheads. It is also used as a substrate for printing graphics

"Floating Light"
Designer: Afroditi Krassa
Manufacturer: Afroditi Krassa
Date: 2001

more: Lights 096–097

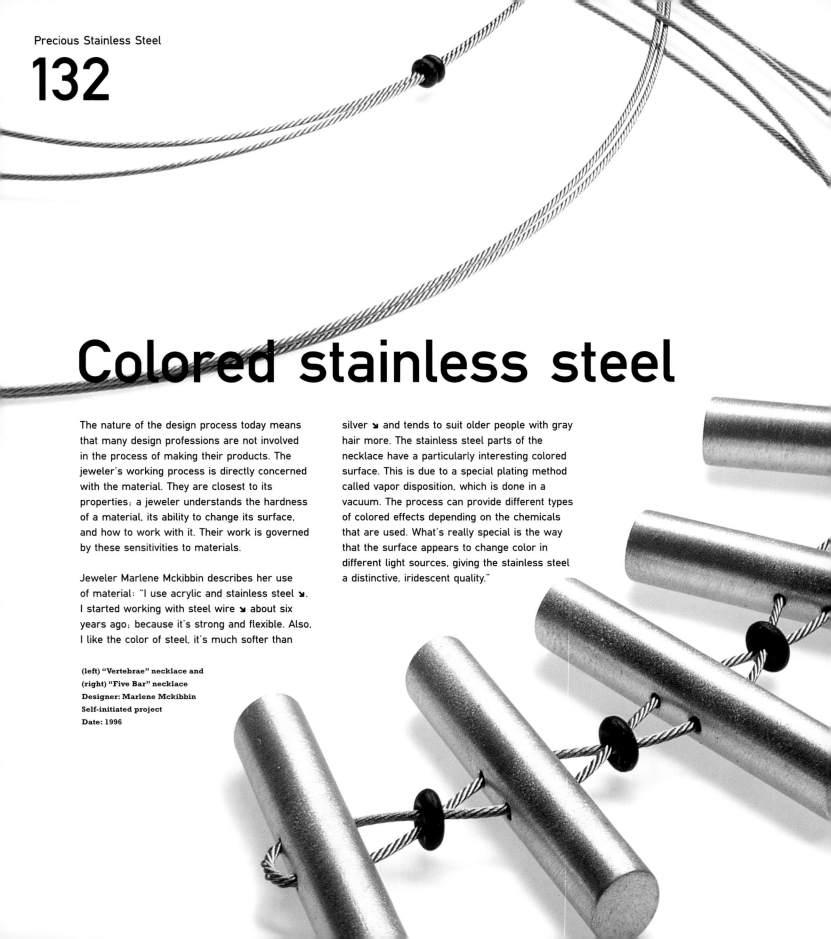

Colored stainless steel

The nature of the design process today means that many design professions are not involved in the process of making their products. The jeweler's working process is directly concerned with the material. They are closest to its properties; a jeweler understands the hardness of a material, its ability to change its surface, and how to work with it. Their work is governed by these sensitivities to materials.

Jeweler Marlene Mckibbin describes her use of material: "I use acrylic and stainless steel ⬎. I started working with steel wire ⬎ about six years ago; because it's strong and flexible. Also, I like the color of steel, it's much softer than

silver ⬎ and tends to suit older people with gray hair more. The stainless steel parts of the necklace have a particularly interesting colored surface. This is due to a special plating method called vapor disposition, which is done in a vacuum. The process can provide different types of colored effects depending on the chemicals that are used. What's really special is the way that the surface appears to change color in different light sources, giving the stainless steel a distinctive, iridescent quality."

(left) "Vertebrae" necklace and
(right) "Five Bar" necklace
Designer: Marlene Mckibbin
Self-initiated project
Date: 1996

Dimensions	**Stainless steel bars 5mm diameter**
Key Features	**Non-corrosive**
	Capable of an outstanding surface finish
	Excellent toughness
	Can be formed using a variety of processes
	Difficult to cold work
More	**www.caa.org.uk**
	www.silversmithing.com
Typical Applications	**Stainless steel has revolutionized industry. Generally used where there is a risk of corrosion and a need for heat-resistance including kitchen equipment, tableware, architectural applications, engine components, fasteners, and tools and dies in production**

more: Silver 014, 018–019, 022–023, 026–027, 084, 092 Stainless steel 018–019, 030, 036–037, 040–041, 046–047, 050–052, 079, 096–097, 106–107, 114–115, 123, 124–125 Steel wire 056–057, 062–062, 076–077

Growing a surface

An anodized ⬎ finish is an aluminum oxide protective skin, which is grown from the aluminum by immersing it in an acid-electrolyte bath and passing an electrical current through it, toughening and significantly thickening its natural oxide coating. There are various forms of anodizing which all produce different finishes, including chromic anodizing, sulphuric anodizing, and hard anodizing. Sulphuric anodizing offers the greatest color variety.

Although anodizing has helped to make aluminum one of the most widely used materials within consumer markets and industry, it is often thought of as a surface finish only for aluminum. However, it is applied to other metals including magnesium, titanium ⬎, zirconium, and zinc ⬎.

Dimensions	**Sizes from 81mm to 424mm long**
Key Features	**Unique decorative surface**
	Durable
	Available in a range of colors
	Corrosion-resistant
More	**www.maglite.com**
	www.anodizing.org
Typical Applications	**Anodizing finishes can be found on engineering components, exteriors of buildings, various interior design applications, domestic appliances, furniture, pens, and exterior panels for aerospace vehicles**

Mini Maglite® flashlight
Designer: Anthony Maglica
Manufacturer: Mag Instruments, Inc.
First introduced: 1979

Hardwearing protection

We are drawn to shiny, reflective surfaces of all kinds, including chrome finishes which reflect so perfectly. Chrome plating ↘ has helped to elevate some products to iconic status, classic cars being the most obvious example. There are three types of chrome plating, which are referred to by various names but can be commonly classified as decorative plating, hard chromium plating, and black chrome plating. The thickness of the chromium layer varies depending on the type. The nature of this kind of plating means that whatever the existing surface of the material, the coating will pick it up, so when plating a matte surface you are left with a matte chrome finish.

When considering chrome plating, it is very important to be aware of the hazards of the process. In recent years, there has been a strong movement away from the traditional hexavalent decorative chromium baths, which are extremely carcinogenic, to the newer trivalent chromium baths, which are considered to be less toxic.

Chrome-based portable fan

Dimensions	**42cm high; 20cm diameter of base**
Key Features	**Decorative**
	Outstanding corrosion resistance
	Low coefficient of friction
	Hard
More	**www.hitechtownroe.com**
	www.sea.org.uk
	www.namf.org
	www.finishing.com
Typical Applications	**Decorative chrome plating is used for kitchenware, tableware, packaging, electronic products, and vehicle components, including door handles and bumpers. Hard chrome plating is used for more industrial applications, including rams on JCBs, components for jet engines, plastic moldings, and shock absorbers. Black chrome plating is used for decoration on musical instruments and solar applications**

more: Chromium 030, 041, 123

Engineering detail

This amplifier is part of a range of high-end audiophile products. It is an example of a functional engineering finish often used in watches (the milled surface retains as much lubricant on the moving parts for as long as possible) that has been decoratively applied to a consumer product. The Jeff Rowland Design Group used this finish for their amplifiers to suggest a technologically-advanced product.

The faceplate is milled from 0.75mm 6061 aircraft aluminum ↘ stock and is machined with a 0.001mm deep fly-cut pattern on a special machine, with a unique diamond-tipped bit. Once the metal is diamond cut, the raw metal is covered with a fine, clear coat to prevent the finish from dulling or oxidizing. No anodizing ↘ is used on the faceplates. The logo is machined into the faceplate and then filled in by hand with gloss black lacquer. Each faceplate is kept in its own metal container to protect the finish until needed.

Model 302 stereo
power amplifier
Designer: Jeff Rowland
and Vertec Tool
Manufacturer: Jeff Rowland
Design Group
Date: 2002

Dimensions	**469mm deep x 254mm high x 368mm wide**
Key Features	**High tolerance**
	Retains lubrication
More	**www.jeffrowland.com**
Typical Applications	**This surface is typically used in engineering applications to retaining oil on a finish. It can also be the by-product of milling a surface to create a tolerant, flat surface**

more: Aluminum 015, 024–025, 034–035, 038–041, 044–045, 048, 053, 060–061, 064–069, 074–075, 078, 080–083, 094–095, 108–109, 112–113, 120–121 Anodizing 134–135

141 Appendices

142

Processing

Casting

Metals are heated and poured into molds. Good for complex parts

Sand-casting

Cost-effective for low-volume production, and allows for complex shapes, but can require a lot of finishing

Investment / Lost wax

This process gives a high degree of consistency and accuracy, and can be used to form complex shapes. It offers an extremely good surface finish for relatively low tooling costs, and is suitable for batch or high-volume production

Injection molding

Used to form complex shapes with high tolerances. Due to the nature of production, no post-finishing is required. However, it is only cost-effective for high-volume production

Die casting

Expensive tooling, which is only justified by high-volume production. However final parts will have a relatively low cost with high tolerances. Can be used to produce parts with thin walls

Spin casting

Ideal for small components. Often used for jewelry. Rubber molds can be used to achieve low tooling costs

Directional solidification

Produces extremely strong superalloy components with superior fatigue-resistance. Allows alloys to exhibit uniform properties throughout their structure with consistent performance from one component to another. The molten superalloy is poured into a mold and then subjected to a highly controlled process of heating and cooling that removes microscopic flaws

Plastic state-forming

The process of heating pre-shaped metals to allow them to be easily formed. Can be labor intensive

Forging

Hammering and pressing metals to form shapes by cold or hot working is one of the simplest and oldest methods of forming metals

Rolling

Hot billets are passed through a series of cylindrical rollers that push the metal into a number of forms to reach the desired shape

Drawn wire

A process where a metal bar is made thinner by drawing it through a series of increasingly smaller dies

Extrusion

A cost-effective way of making continuous lengths of solid or hollow shapes with the same cross-sectional shape. Can be used with either hot or cold metal

Impact extrusion

A method of producing small- to medium-sized components without the need for a draft angle. It allows for rapid production and can tolerate varying wall thicknesses. Low tooling costs

Powder metallurgy (PM)

A method of manufacturing both ferrous and non-ferrous components. Involves mixing powdered alloys and compacting the mixture in a die. The resultant shapes are then sintered or heated to bond the particles metallurgically. The process eliminates machining, and uses 97 percent of the original raw material. Different metal powders can be used to fill different parts of the mold

Solid state-forming

The starting point is a bar, sheet, or another solid piece of metal which can then be shaped at room temperature. Can be labor intensive. Can require low capital costs for tooling

Spinning
A very common process used to produce symmetrical round parts, e.g. saucers, cups, and cones. A sheet of metal is pushed around a mold while both are spinning on a lathe. This process can be used for batch, low-, or high-volume production.

Bending
An economical production method used for forming any type of sheet, rod, or tube material

Continuous roll forming
Feeding sheet metal through rollers to produce long lengths with the same cross-sectional shape. Similar to extrusion, but the walls are limited to a single thickness. It is most cost-effective for high-volume production

Drawing
A sheet of metal is pressed between a male and female die. It is used to form both shallow and deep hollow shapes

Metal cutting

Sheet

Punching
A low- or high-volume production method whereby a tool is used to cut out shapes from a sheet of metal

Blanking
The same as punching but, instead of the shape being used, the background from which the shape is cut is used

Shearing
Cutting sheet material by shearing; similar to cutting a piece of paper by holding a pair of scissors in the optimum position

Machining

Chip forming
Includes a number of processes for cutting metals, where chips are formed by cutting into the material. These include drilling, boring, milling, lathe work, grinding, and sawing

Non chip forming
Shaping metals from an existing bar or sheet, etc, but without the by-product of chips. Processes include chemical machining, acid-etching, electric discharge machining, abrasive jet machining, laser cutting, water jet cutting, and thermal cutting

Metal terms

Alloy
A metal composed of two or more elements

Allotropy
The existence of an element in more than one physical form: liquid, solid, or gaseous in a single phase of matter. Carbon is allotropic, as it can exist in more than one form—graphite or diamond

Annealing
A general term to describe the process of creating a soft state in materials. In contrast to hardening methods, annealing is used to soften and de-stress a material. It involves the metal being heated and/or cooled slowly. The process brings about a relaxing of the internal stresses in the material. Also used within glass production

Anodizing
A process of protecting the surface of a metal by increasing the thickness of the natural oxide on the material. Anodizing can be applied to aluminum, magnesium, titanium, zirconium, and zinc

Austentic
A high-density and high-temperature form of iron. Austentic stainless steels are usually used for applications where corrosion-resistance and toughness are important considerations

Carbon steel
An alloy of carbon and steel. The amount of carbon affects the hardness of the steel. Low carbon steels are soft; high carbon steels are harder

Case hardening
Used to produce a hard surface layer in steel. There are two main methods: one is to increase the carbon content in the surface of the steel, followed by quenching and light tempering; the second is to heat the surface and then quench and temper the material. Case hardening is important if a certain part has to resist wear, for example a sword which should be sharp but have a degree of flexibility

Cermets
Composite materials of ceramic particles in a metal matrix

Cold working
Working and forming metal at a temperature below that at which it recrystallizes. (See also work hardening)

Ferrous
Metals containing iron. Ferrous metals are largely made up of various forms of steel and iron

Forging
Hammering and pressing metals to form shapes by cold or hot working is one of the simplest and oldest methods of forming metals

Galvanizing
A surface treatment where zinc is applied over steel or iron. Commonly seen on metal gardening containers

Martensitic stainless steels
High hardness and high tensile strength steels

Noble metal
Characterized by a high resistance to corrosion. Generally applied to precious metals

Non-ferrous
Metals that do not contain iron as a main ingredient. Examples of non-ferrous metals include aluminum, copper, magnesium, and zinc, and precious metals like silver, gold, and platinum

Pewter
A tin-lead alloy that has been used for domestic containers for centuries. Modern pewter is likely to contain lead and antimony

Precious metals
Silver, gold, and the platinum-group metals

Quenching
A method of hardening a metal by quickly cooling it using water, oil, air, or molten-metal baths. However, this method also increases its brittleness. Quenching a metal in water cools it at a quicker rate than oil

Refractory metals
Metals with a high melting temperature. These include tungsten, nickel, chromium, molybdenum, platinum, and zirconium

Smelting
A process of separating a metal from its ore

Superalloy
Heat-resistant or high-temperature alloys capable of performing at temperatures above 1000°C (1832°F) with little or no corrosion

Tempering
Reduces the hardness of steel by relieving the stresses in the material. The process involves heating the steel to a temperature below the transformation range and then cooling it slowly in air

Work hardening
The process of bending a piece of metal continuously. It becomes increasingly hard and difficult to bend until it eventually breaks. Annealing at regular intervals allows for further deformation

Mechanical properties

Material properties are used informally in this book. However, when referring to toughness, it is important that the correct meaning is understood and how it is different to hardness. There are many properties used in evaluating materials. Below are listed some of the most frequently used terms encompassing mechanical, chemical, and thermal properties.

Brittleness
Used to describe a material that breaks without giving any visible signs or without prior deformation

Compressive strength
The force applied to a material that shortens the length and widens the cross-sectional area. The opposite to tensile strength

Conductivity
The speed at which a material transfers energy through heat or electricity

Creep
The amount a material slowly distorts under pressure

Ductility
The ability of a material to be permanently deformed under tension without fracturing

Elasticity
The ability a material has to return to its original dimensions when a force has been applied

Fatigue strength
The ability of a material to withstand repeated force or pressure

Flash point
The lowest temperature at which a material or its vapor ignites

Hardness
A hard material is one that resists indentation, scratching, wear, and abrasion, and is difficult to machine

Hygroscopic
A material which absorbs and retains moisture easily

Impact strength
The ability of a material to absorb the energy of a sudden blow

Malleability
The ease with which a material is deformed permanently by compression without fracturing

Plasticity
The ease with which a material permanently deforms under low pressure

Porosity
The volume of open pores in a material in relation to the overall volume of that material

Shear strength
This is the action of two forces working in opposite directions over a piece of material forcing part of the material to slip over another; the point at which a fracture occurs under a load

Specific gravity
The weight of a given volume of a material compared with the weight of an equal volume of water at 4°C (39.2°F)

Specific heat
Energy required to heat 1g of a given material by 1°C (33.8°F)

Stiffness
The ability of a material to withstand deflection. Based on the ratio of stress to movement

Static strength
The ability of a material to withstand an applied stress resulting in deformation

Stress
Tensile stress, compressive stress, or shear stress is the pressure externally applied to a material, which causes a fracture

Tensile strength
The amount of stress that a material is able to withstand when stretched. The opposite to compressive strength

Thermal expansion
The ratio between the increase in temperature and the increase in dimension of the material

Toughness
The ability of a material to absorb impact energy without breaking

CONVERSION TABLE: MILLIMETERS TO INCHES

mm	inch	mm	inch	mm	inch	mm	inch
1	0.03937	26	1.02362	60	2.36220	310	12.20472
2	0.07874	27	1.06299	70	2.75590	320	12.59842
3	0.11811	28	1.10236	80	3.14960	330	12.99212
4	0.15748	29	1.14173	90	3.54330	340	13.38582
5	0.19685	30	1.18110	100	3.93700	350	13.77952
6	0.23622	31	1.22047	110	4.33070	360	14.17322
7	0.27559	32	1.25984	120	4.72440	370	14.56692
8	0.31496	33	1.29921	130	5.11811	380	14.96063
9	0.35433	34	1.33858	140	5.51181	390	15.35433
l0	0.39370	35	1.37795	150	5.90551	400	15.74803
11	0.43307	36	1.41732	160	6.29921	410	16.14173
12	0.47244	37	1.45669	170	6.69291	420	16.53543
13	0.51181	38	1.49606	180	7.08661	430	16.92913
14	0.55118	39	1.53543	190	7.48031	440	17.32283
15	0.59055	40	1.57480	200	7.87401	450	17.71653
16	0.62992	41	1.61417	210	8.26771	460	18.11023
17	0.66929	42	1.65354	220	8.66141	470	18.50393
18	0.70866	43	1.69291	230	9.05511	480	18.89763
19	0.74803	44	1.73228	240	9.44881	490	19.29133
20	0.78740	45	1.77165	250	9.84252	500	19.68504
21	0.82677	46	1.81102	260	10.23622		
22	0.86614	47	1.85039	270	10.62992		
23	0.90551	48	1.88976	280	11.02362		
24	0.94488	49	1.92913	290	11.41732		
25	0.98425	50	1.96850	300	11.81102		

1 mm = 0.03937 inch		1 cm = 0.3937 inch	1 m = 3.281 feet
1 inch = 25.4 mm		1 foot = 304.8 mm	1 yard = 914.4 mm

CONVERSION TABLE: INCHES TO MILLIMETERS

inch		mm	inch		mm	inch		mm
1/64	0.01565	0.3969	3/8	0.375	9.5250	47/64	0.734375	18.6531
1/32	0.03125	0.7938	25/64	0.390625	9.9219	3/4	0.750	19.0500
3/64	0.046875	1.1906	13/32	0.40625	10.3188			
1/16	0.0625	1.5875	27/64	0.421875	10.7156	49/64	0.765625	19.4469
						25/32	0.78125	19.8438
5/64	0.078125	1.9844	7/16	0.4375	11.1125	51/64	0.796875	20.2406
3/32	0.09375	2.3812	29/64	0.453125	11.5094	13/16	0.8125	20.6375
7/64	0.109375	2.7781	15/32	0.46875	11.9062			
			31/64	0.484375	12.3031	53/64	0.828125	21.0344
1/8	0.125	3.1750				27/32	0.84375	21.4312
9/64	0.140625	3.5719	1/2	0.500	12.700	55/64	0.858375	21.8281
5/32	0.15625	3.9688	33/64	0.515625	13.0969			
11/64	0.171875	4.3656	17/32	0.53125	13.4938	7/8	0.875	22.2250
			35/64	0.546875	13.8906	57/64	0.890625	22.6219
3/16	0.1875	4.7625	9/16	0.5625	14.2875	29/32	0.90625	23.0188
13/64	0.203125	5.1594				59/64	0.921875	23.4156
7/32	0.21875	5.5562	37/64	0.578125	14.6844			
15/64	0.23437	5.9531	19/32	0.59375	15.0812	15/16	0.9375	23.8125
1/4	0.250	6.3500	39/64	0.609375	15.4781	61/64	0.953125	24.2094
						31/32	0.96875	24.6062
17/64	0.265625	6.7469	5/8	0.625	15.8750	63/64	0.9843752	25.0031
9/32	0.28125	7.1438	41/64	0.640625	16.2719			
19/64	0.296875	7.5406	21/32	0.65625	16.6688	1	1.00	25.4
5/16	0.3125	7.9375	43/64	0.671875	17.0656			
21/64	0.1328125	8.3344	11/16	0.6875	17.4625			
11/32	0.34375	8.7312	45/64	0.703125	17.8594			
23/64	0.359375	9.1281	23/32	0.71875	18.2562			

Measurements are in metric with imperial equivalents. Readers should be aware that conversions may have been rounded up or down to the nearest convenient equivalent. Where a measurement is absolute no conversion has been made.

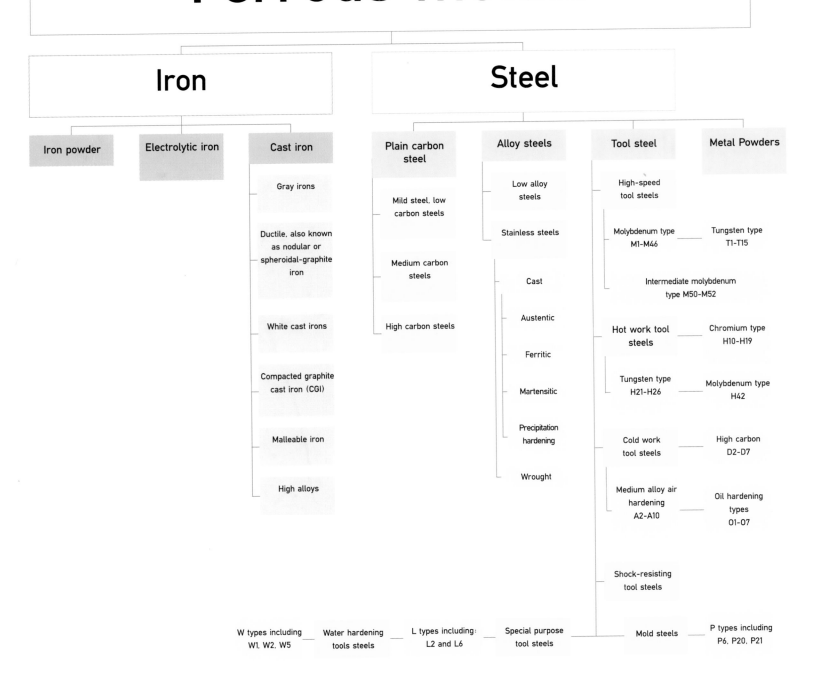

Ferrous metals

Iron

- Iron powder
- Electrolytic iron
- Cast iron
 - Gray irons
 - Ductile, also known as nodular or spheroidal-graphite iron
 - White cast irons
 - Compacted graphite cast iron (CGI)
 - Malleable iron
 - High alloys

Steel

- Plain carbon steel
 - Mild steel, low carbon steels
 - Medium carbon steels
 - High carbon steels

- Alloy steels
 - Low alloy steels
 - Stainless steels
 - Cast
 - Austentic
 - Ferritic
 - Martensitic
 - Precipitation hardening
 - Wrought

- Tool steel
 - High-speed tool steels
 - Molybdenum type M1-M46 — Tungsten type T1-T15
 - Intermediate molybdenum type M50-M52
 - Hot work tool steels
 - Tungsten type H21-H26 — Chromium type H10-H19
 - — Molybdenum type H42
 - Cold work tool steels
 - — High carbon D2-D7
 - Medium alloy air hardening A2-A10 — Oil hardening types 01-07
 - Shock-resisting tool steels
 - Mold steels — P types including P6, P20, P21
 - Special purpose tool steels — L types including: L2 and L6
 - Water hardening tools steels — W types including W1, W2, W5

- Metal Powders

Non-ferrous metals

Light alloys

Aluminum (Al)	Magnesium (Mg)	Zinc (Zn)	Titanium (Ti)	Beryllium (Be)
Wrought alloys	Alloys	Casting alloys	Titanium alpha alloys	
Casting alloys	Aluminum (A)	Standard die-casting alloys	Titanium alpha-beta alloys	
Aluminum matrix composites	Rare Earth (E)	ZA casting alloys	Titanium beta alloys	
Superelastic aluminum	Thorium (H)	Wrought alloys		
	Zirconium (K)			
	Lithium (L)			
	Manganese (M)			
	Silver (Q)			
	Silicon (S)			
	Zinc (Z)			

Precious metals

Gold (Au)	Silver (Ag)	Platinum group
	Sterling silver	Platinum (Pt)
	Fine silver	Palladium (Pd)
	Coin silver	Iridium (Ir)
	Silver powder	Rhodium (Rh)
		Ruthenium (Ru)
		Osmium (Os)

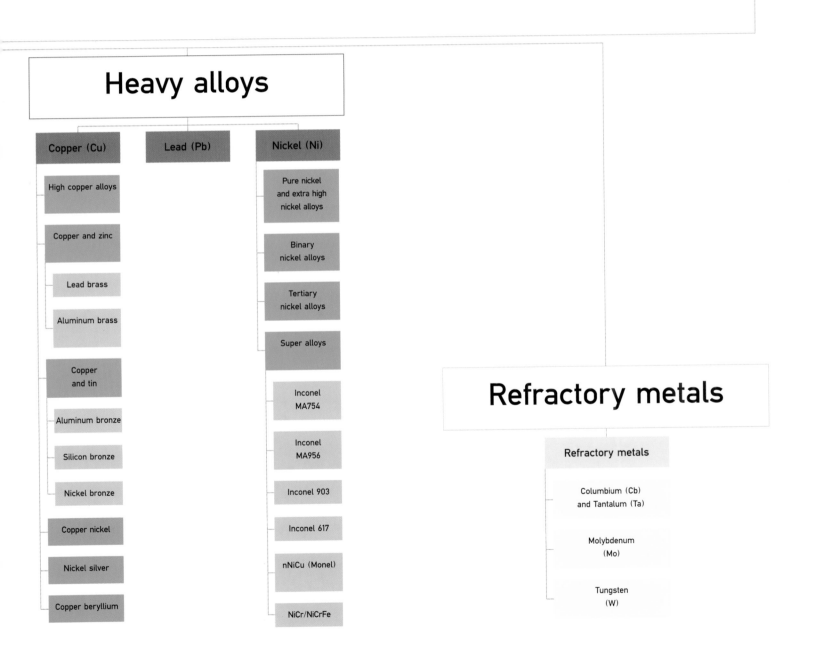

Heavy alloys

Copper (Cu)

High copper alloys

Copper and zinc

Lead brass

Aluminum brass

Copper and tin

Aluminum bronze

Silicon bronze

Nickel bronze

Copper nickel

Nickel silver

Copper beryllium

Lead (Pb)

Nickel (Ni)

Pure nickel and extra high nickel alloys

Binary nickel alloys

Tertiary nickel alloys

Super alloys

Inconel MA754

Inconel MA956

Inconel 903

Inconel 617

nNiCu (Monel)

NiCr/NiCrFe

Refractory metals

Refractory metals

Columbium (Cb) and Tantalum (Ta)

Molybdenum (Mo)

Tungsten (W)

General metals

www.magnesium.com

Resource for the magnesium industry

www.members.tripod.com/Mg

Unofficial magnesium home page. Although this was the first comprehensive magnesium home page, new entrants now claim "official" status. A website for those interested in magnesium metal production and the production of magnesium metal components

www.zinc.org

American Zinc Association

www.specialmetals.com

Special Metals is the world's leading inventor and producer of nickel-based superalloys

www.thecdi.com

The Cobalt Development Institute

www.tintechnology.com

Tin Technology is a membership-based organisation involved in the research, development, and marketing of tin-based technologies

www.leadtin.com

Information on lead and tin. Also good for metal associations

www.titanium.org

International Titanium Association

www.titaniuminfogroup.co.uk

Titanium Information Group

www.nidi.org

The Nickel Development Institute is an international non-profit organisation

www.manganeseinstitute.com

A non-profit industry association that represents manganese ore and alloy producers, manufacturers of manganese-based products, and traders worldwide

www.abms.com

For over 75 years ABMS has served as a primary source of metal statistics. They get much of their data directly from reporting companies on a confidential basis

www.zipperling.de

Ormecon is the first company worldwide to offer an organic metal

Aluminum

www.alufoil.org

European Aluminiun Foil Association

www.aluplanet.com

General information on aluminum

www.reynaers.com

Aluminum components for architecture

www.aluminum.org

The Aluminum Association, Inc.

www.c-a-b.org.uk

Council for aluminum in building

www.world-aluminum.org

International Aluminum Institute

www.eaa.net

European Aluminum Association

www.alfed.org.uk

UK Aluminum Federation

www.alupro.org.uk

UK Aluminum Packaging Recycling Organisation

www.aluminumbydesign.org

Excellent website with design-based products and information on aluminum

Steel

www.corusgroup.com

Leading global supplier to the metal industry

www.key-to-steel.com

Comprehensive steel properties database, developed and designed for professional use worldwide

www.steel.org

American Iron and Steel Institute

www.issb.co.uk

Iron and Steel Statistics Bureau

www.uksteel.org.uk

Trade association for the UK steel industry

www.steelalliance.com

North American Steel Alliance

www.worldsteel.org

International Iron and Steel Institute

www.bssa.org.uk

Stainless Steel Association

www.worldstainless.org

International Stainless Steel Forum

General materials

www.modulor.de
Great source for a wide range of materials for modelmaking, product, and graphic design, presentation, decoration, and advertising

www.iommms.org
International Organization of Materials, Metals, and Minerals Societies. Many useful links

www.fems.org
Federation of European Materials Societies

www.matersci.net
Database of internet resources related to materials science and metallurgy

www.sf2m.asso.fr
French Society of Metallurgy and Materials

www.metalsontheweb.co.uk
Offers the small or occasional metal user a full range of non-ferrous metals and stainless steel

www.tms.org
Headquartered in the US but international in both its membership and activities, The Minerals, Metals, and Materials Society is a professional organization that encompasses the entire range of materials and engineering, from minerals processing and primary metals production to basic research and the advanced applications of materials

www.azom.com
Materials information, supplier, and expert directory. Excellent for information on all classes of materials

www.metalworld.com
MetalWorld is a worldwide information trading site that promotes trade in the metals industry

www.key-to-metals.com
Comprehensive database of non-ferrous metals including aluminum, copper, titanium, magnesium, tin, zinc, lead, nickel, and more

www.techstreet.com
500,000 technical information titles including one of the world's largest collections of industry standards and specifications

www.asm-intl.org
Materials Information Society

www.icme.com
International Council on Mining and Metals

www.instmat.co.uk
UK Institute of Materials, Minerals, and Mining

www.msci.org
Metal Service Centre Institute. Members' database of metals producers

wwwhere.else

Precious metals

www.ipmi.org

The International Precious Metals Institute is an association of producers, refiners, fabricators, scientists, users, financial institutions, merchants, private and public sector groups, and the general precious metals community. Hosts a forum for the exchange of information and technology

www.goldinstitute.org

The Gold Institute

www.silverinstitute.org

The Silver Institute

www.silversmithing.com

Society of American Silversmiths

www.panamericansilver.com

The Pan American Silver Corporation is a mining company focused exclusively on silver

www.apecs.com.au

Specialist casters of precious metals

www.gold.org

World Gold Council

Copper and Brass

www.brass.org

Brass website of the Copper Development Association

www.copper.org

A service of the Copper Development Association for the US copper and brass industries

www.cda.org.uk

Copper Development Association

www.icsg.org

International Copper Study Group

www.coppercouncil.org

International Wrought Copper Council

www.copperinfo.com

The International Copper Association Ltd.

Production

www.metalbot.com

Specialists all forms of metal castings and other metal forming processes. They have a very good page detailing each casting method

http://search.sheetmetalworld.com

Sheet Metal World provides internet-related services and information to and for the sheet metal fabrication industry

www.castmetals.com

Cast Metals Institute, Inc.

www.metalforming.com

Precision Metalforming Association

www.castmetalsfederation.com

Cast Metals Federation

www.canmakers.co.uk

Canmakers represents UK manufacturers of beer and carbonated soft drinks cans

www.mpif.org

Metal Powder Industries Federation

www.minalex.com

Manufacturers of aluminum extrusions

www.aluminum-components.hydro.com

Hydro Aluminum Components provides raw materials, manufactures extruded sections and sheet, and is a leading partner to the building and automotive industries

www.aec.org

Aluminum Extruders Council

www.sme.org

Society of Manufacturing Engineers

http://amc.aticorp.org/

US Metal Casting Consortium

www.castingsdev.com

Castings Technology International. Undertakes research and development and provides a wide range of impartial technical services for casting producers and users worldwide. These services cover all aspects of the design, materials, manufacture, use, quality, and performance of castings

www.foundryonline.com

Information and links on a range of casting methods

Surface

www.metals4design.com

Corus website for pre-finished metals

www.corrosionsource.com

A wealth of information on corrosion

www.aesf.org

American Electroplaters and Surface Finishers Society

www.glass-on-metal.com

An online enamelling resource

www.pkselective.com

US-based anodizing service

http://corrosion-doctors.org

Promotes general awareness of corrosion causes and solutions

www.sea.org.uk

Surface Engineering Association

www.galvanizeit.org

US Galvanizers Association

www.uk-finishing.org.uk

Institute of Metal Finishing

www.coatings.org.uk

Coatings Federation

www.anodizing.org

Aluminum Anodizers Council

www.metalfinishes.com

Interesting site for sprayed metal finishes

Semi-finished

www.qdfcomponents.com

Cast iron metal components

www.acmealliance.com

Component manufacturer including magnesium die casting, aluminum extrusion, and sheet metal stampings

www.sma-inc.com

Producers of shape memory metals

www.memory.com

US-based producers of shape memory metals

www.dynalloy.com

A manufacturer of shape memory alloys specially made for actuators

www.ashlacyperf.co.uk

Europe's leading manufacturer of perforated materials

www.shapesllc.com

Aluminum extrusions

www.swicofil.com/rstat.html

Metal yarns

www.wboms.sagenet.co.uk

World Bureau of Metal Statistics. A consultancy and publishers of metal information on annual consumption, cost etc.

www.onlinemetals.com

US-based suppliers of small quantities of metal

www.alcoa.com

World's leading producer of primary aluminum, fabricated aluminum, and alumina. Active in all major aspects of the industry—technology, mining, refining, smelting, fabricating, and recycling

www.asm-intl.org

International Society of Materials Engineers and Scientists

With thanks and acknowledgments to: 004 Zanotta and Pietro Arosio 006 Materials and Aerospace Corporation, photography by Xavier Young; 014 Photography by Xavier Young; 015 Apple Computers; 016–017 Con Edison and Karim Rashid; 018–019 Stelton and Arne Jacobsen; 020–021 Skultuna Messingsbruk and Olof Kolte Design; 022–023 Marlene Mckibbin, photography by Xavier Young; 024 LINDBERG; 025 Gillette, photography by Xavier Young; 026–027 Royal Copenhagen A/S, Georg Jensen, and Henning Kopel; 028 Mont-blanc; 029 Malvinus, Alfred Haberli, and Christophe Marchand; 030 Alessi; 031 Vitra and Ron Arad; 034–035 OMK Design and Rodney Kinsman; 036–37 Rolls Royce, Polycast Ltd., and Charles Robinson Sykes; 038–039 Zanotta and Pietro Arosio; 040 OMK Design and Rodney Kinsman; 041 Keltum and Gijs Bakker; 042–043 Corus Space; 044–045 Nambe and Karim Rashid; 046–047 Purves & Purves and Ben Panayi, photography by Xavier Young; 048 Rexam; 049 Full Blown Metals and Stephen Newby, photography by Joseph Hutt; 050-051 P.I. Castings Ltd., photography by Xavier Young; 052 Sam Buxton; 053 Sigg Switzerland AG; 054–055 BJS Electroforming;

056–057 Whitecroft Lydney Ltd, photography by Xavier Young 060–061 Lemark, photography by Xavier Young; 062–063 Memory-Metalle GmbH; 064–065 Alusion, photography by Xavier Young; 066–067 Alucobond, photography by Xavier Young; 068–069 Materials and Aerospace Corporation, photography by Xavier Young; 070–071 Corus Space; 074–075 Ingo Maurer; 076–077 Takeshi Ishiguro, photography by Richard Davies; 078 Lotus and Julian Thompson; 079 LINDBERG; 080–081 Audi; 082–083 Superform Aluminum and Ron Arad; 084 Ted Noten; 085 Issey Miyake; 086–087 Ane Christiansen; 082–083 Global and Komin Yamada, photography by Xavier Young; 090–091 Acme Whistles, photography by Xavier Young; 092 Afroditi Krassa; 093 Corus Space, Phaidon, and Mark Diaper; 094–095 SUCK-UK and Ken Hirose, photography by Xavier Young; 096–097 Alvaro Catalan de Ocon, photography by Xavier Young; 098–099 Photography by Xavier Young; 102–103 Herman Miller Inc. and Stephen Peart; 104 Michael Hopkins & Partners and the Parliamentary Works Directorate, photography by Richard Davies; 105 Idaho, Tom Longhurst,

and Simon Procter; 106–107 Knoll Textiles and Suzanne Tick, photography by Xavier Young; 108–109 Charisma; 110 Jean Nouvel and GIMM Architekten; 112–113 © Guggenheim Museum Bilbao 114–115 Clauss Markisen and Projekt GmbH; 116–117 Gebr Kufferath AG; 120–121 Boris Bally, photography by J.W. Johnson; 122 Blu Dot, John Christakos, Charles Lazor, and Maurice Blanks; 123 Dornbracht and Massimo Iosa Ghini; 125 Doh Partnership, photography by Doh Partnership; 126 Photography by Xavier Young; 128–129 BJS Electroforming, photography by Stuart Graham; 130–131 Afroditi Krassa; 132–133 Marlene Mckibbin, photography by Xavier Young; 134–135 Maglite and Anthony Maglica, photography by Xavier Young; 136–137 Photography by Xavier Young; 138–139 Jeff Rowland and Vertec Tool.

Thanks to the many people who are too numerous to mention but who have supplied images and taken the time to describe the various aspects of their materials and production methods.

Thanks especially to Paul Berrow at Prym Whitecroft for showing this curious designer how paper clips are produced. Many thanks to Anna Frohm for her invaluable research efforts. Thanks also to Mike Stainton at Lotus for his unrivalled help with the Lotus Elise feature, and to Charlotte Morin for her French to English translations. To Margaret Pope for her features ideas and also her solid support throughout this series. And thanks to Central Saint Martin's College of Art and Design for their support of this book. To Terry and Terry who should have had a big thank you a long time ago. Many thanks and also big congratulations to Thalia and Andrew.

Special thanks to Ron Arad for all his features in the Materials series and for sharing his thoughts in the foreword to this book.

Thanks again to everyone at Rotovision. In particular to Editors Becky Moss and Leonie Taylor who have again been fantastic people to work with. And big thanks to Art Director Luke Herriott, Designer Lucie Penn, and Photographer Xavier Young, for their creative input.

Finally thank you to my beautiful angel Alison for her advice and ideas, and for her complete faith.

Thank you

Index

Index

THE BISHOP'S STORTFORD HIGH SCHOOL LIBRARY